GALASHIELS
THROUGH TIME
Sheila Scott

AMBERLEY PUBLISHING

First published 2010

Amberley Publishing Plc
Cirencester Road, Chalford,
Stroud, Gloucestershire, GL6 8PE

www.amberley-books.com

ISBN 978 1 4456 0040 6

British Library Cataloguing in Publication Data.
A catalogue record for this book is available from
the British Library.

Typeset in 9.5pt on 12pt Celeste.
Typesetting by Amberley Publishing.
Printed in the UK.

Introduction

I have long believed we should not dwell in the past but learn from it. Putting together this book has certainly given me the opportunity to do just that. It has been a great experience being able to photograph new images and read further into the history of the town. I thank Amberley Publishing for asking me to do it on their behalf.

Having been a professional photographer in the town for over twenty years, I have become aware that I am playing a small part in a historical recording process, started many years ago by previous photographers. They probably never gave a thought to the interest that would be shown in their work so many years on. I hope with this book I have given future photographers something to work from when they produce the next version in 100 years time!

I have been fortunate to have records and memories from both my mother and father's families who both had strong connections with the town. My great grandfather Andrew Walker moved to the town in the mid to late 1800s to work as a Slater. His son – my grandfather James Walker (born Church Street in 1885 ran a post office and general store in Huddersfield Street for thirty-three years, and my mother, Margaret working for Goodsirs (cabinet makers and furnishers) and R.P. Adam (Dry-salter's).

The book has been compiled with the help of memories left by them. The following poem was found written in my grandfathers memoirs in the 1950s and I feel the words are as appropriate and meaningful today as they were then.

> The auld toun's disappearing, the hoose's bit by bit.
> The auld folks either deeing or else they're havin tae flit.
> But the Cross is still standing, it'll stand a lang, lang time,
> Tae mind the lads of Gala and the days o' auld lang syne.

I doubt there has been such a change in appearance in any other Border town as there has been in Galashiels over the last ten years. Galashiels is rich in history – in its heyday the centre of the Scottish Textile Industry. It was known for woollens by 1733 but earliest indication of the woollen trade in the town is contained in a manuscript (Mr Scott of Gala) dated 1581 when "waulkmills" are mentioned as pertinents belonging to the barony.

Large, grand mansion houses, built by mill owners' new found wealth, are still to be seen in the town, however many have now been converted to flats or a hotel in the case of Kingsknowes. The town's mills and chimneys long gone with the demise of the industry, having been

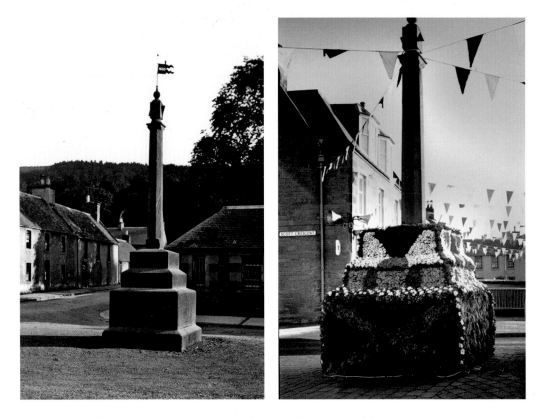

Photographs show Old Town Cross and also decorated for Braw Lads' Day 2000.

replaced with large shopping complexes which now offer the townsfolk work in retail rather than mills. The controversial closure of the railway back in 1969 is proving as controversial in 2010 with the proposed return of a line to Galashiels planned for 2014? We shall see!

Although the textile industry is all but lost we still have the famous College of Textiles, although now known as Heriot Watt University, with a splendid campus facility in Netherdale. This attracts students from others parts of the world to the town to learn design and business management.

A friend from Galashiels recently holidayed in India and, on hearing his accent, a young Indian gentleman asked where he came from. The usual reply "near Edinburgh" did not suffice and on being pressed my friend said, 'Galashiels'. On hearing this the young lad said "I come frae Beech Avenue". He was a student at Heriot Watt University and was home in New Delhi for the holidays!

In 1622 over 400 people lived in Galashiels. In 2010 we have a town of 14,361, albeit much changed in appearance, but one which is multi cultural, friendly, and above all full of history.

I hope you get as much enjoyment browsing the pages of this book as I did in putting them together.

Fishmongers

The arrival of the railway to Galashiels in 1849 brought many benefits, not least the easy transportation of coal to power the tweed mills' looms, replacing water power. It also allowed fishwives from Newhaven to sell fresh fish in The Borders. This traditional garbed fishwife with her creel and basket was photographed by Kirkwood of 21 Bridge Street around 1860. The recent image shows Dave Crichton with Julia Noble in Noble's Fishmongers in Bank Street. Fishmongers have been in these premises for approximately 100 years.

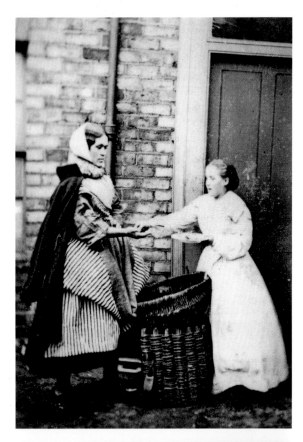

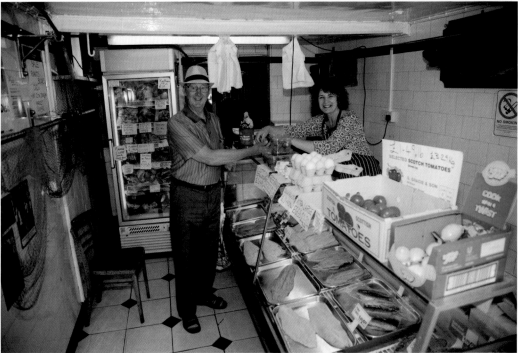

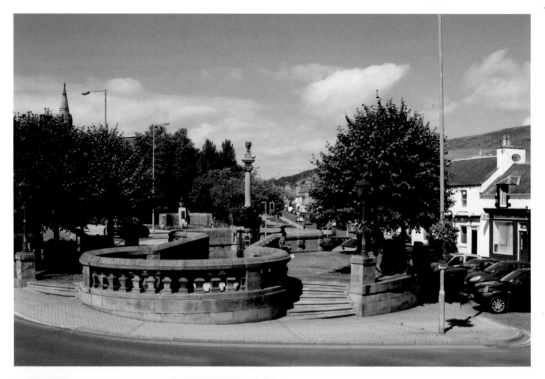

Bank Street

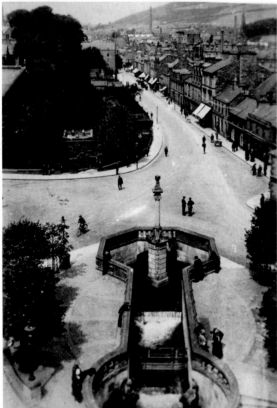

Bank Street and the fountain, *c.* 1925, is almost impossible to replicate as it was probably taken from the clock tower of the memorial when it was being built. Bank Street, however, does not look so different now in its layout, other than change of shop ownership and the amount of traffic which requires a pedestrian crossing for safety.

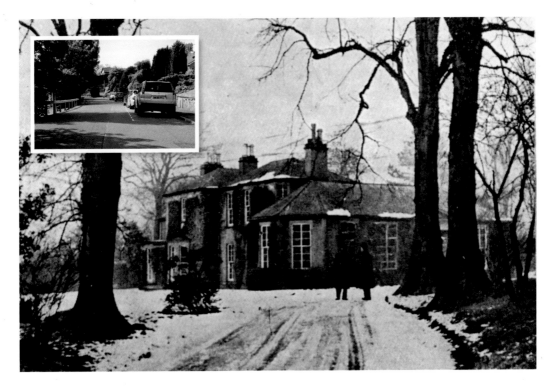

Ladhope House

Ladhope House, long gone, is now a large private housing estate entered from High Buckholmside. The image from 1907 shows the Lodge House and drive at the end of the High Road. Unlike this tranquil scene, the road is now used as a traffic 'short cut' from the A7 to the Melrose Road.

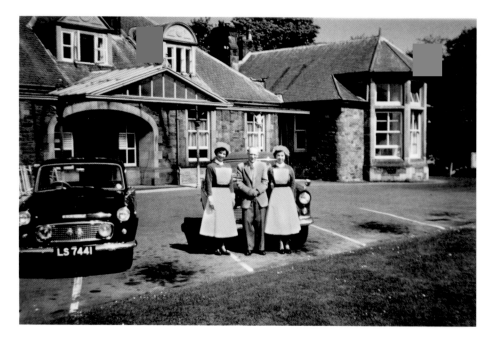

The Cottage Hospital

Having been the local hospital since 1893, 'The Cottage' stopped being used as a maternity and general unit in recent years and became a psychiatric unit. Sister Neta Weatherly is pictured here in 1959 with Dr. Anthony and Sister Midwife Mary Dickson. Sister Weatherly became Matron, and was in charge of approximately fifteen maternity and twenty-two general beds. The hospital grew their own vegetables, had their own kitchens and laundry, performed operations every Tuesday and removed tonsils and adenoids every Friday. The cottage also had its own X-ray and casualty department. The outside now is relatively unchanged.

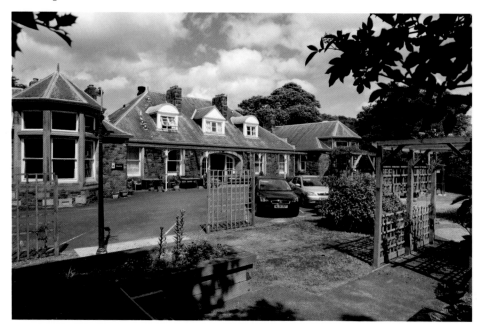

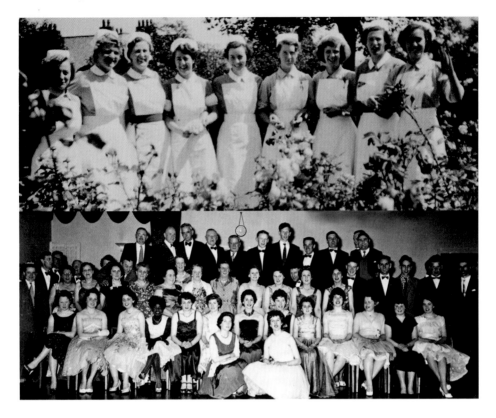

Maternity Unit

Many local people have fond memories of the maternity unit within The Cottage Hospital. Pictured is Sister Effie Devlin who retired in 1984 alongside Sister Joanne Ballantyne. Their 'service' for mothers was a seven-day stay after the birth, with the husband being allowed, for just one night, to take his wife out while the midwives did the babysitting. A great treat along with the milk stout allowed during the stay! Changed days indeed. The other image shows a hospital night out with nurses and doctors, and a group of young nurses in the gardens in 1956.

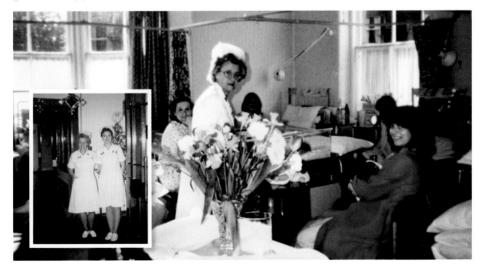

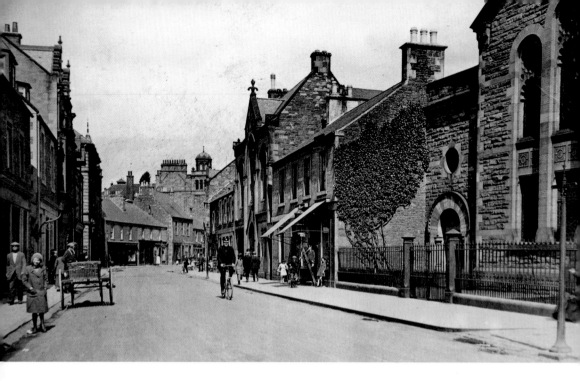

The High Street

The road layout is similar apart from the pedestrian crossing outside Trinity Church. It is now a requirement for the two lane, one way traffic, something not necessary in the thirties.

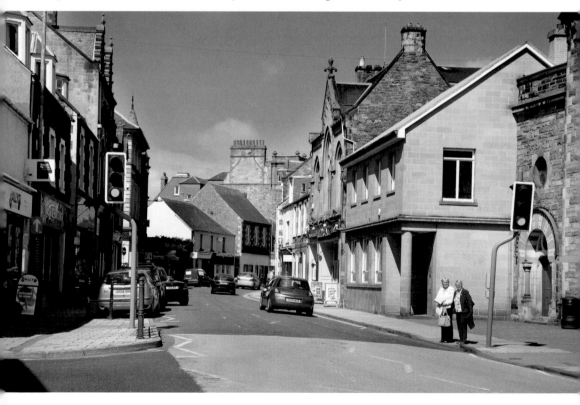

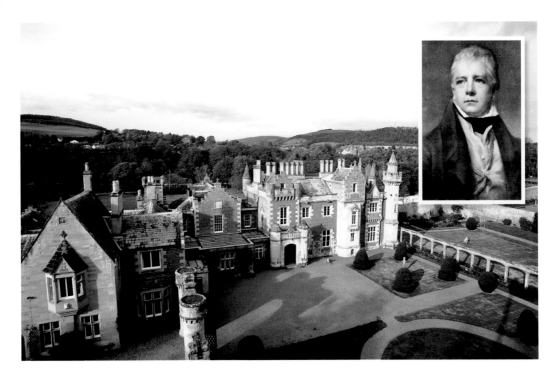

Abbotsford House

Home of Sir Walter Scott, who was born 1771. In 1812 he had moved there from Ashiesteel, having purchased the property known as Cartley Hole (seen in the old image) on which he built Abbotsford. He was the first to wear a pair of trousers made of Scottish shepherd check plaid. It is a custom for these checks to be made for, and worn by all Braw Lads on the Gala Day.

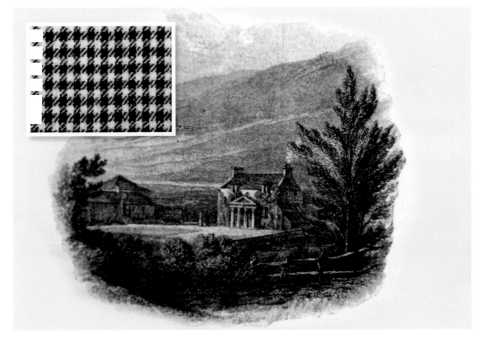

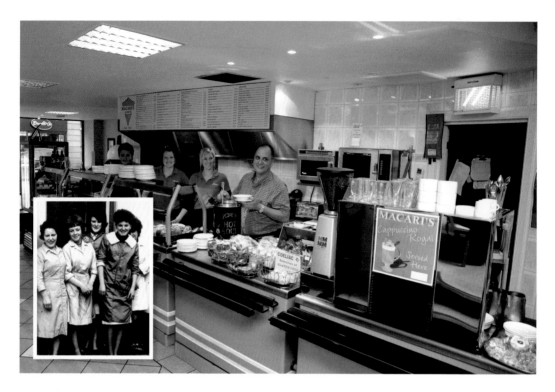

Macari's

Giovanni was the first of the Macari family to come to Galashiels, opening The Gala Soda-Fountain in 1924. He was followed by his son Tony and in turn, his son Phillip who now runs the Macari family business in the town (seen here in the same premises today). The inset image also shows sister Sylvia alongside café girls in 1965 Nikki Fitzgerald, Maria Macari and Christine Reid.

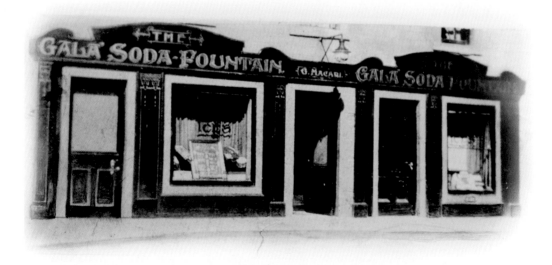

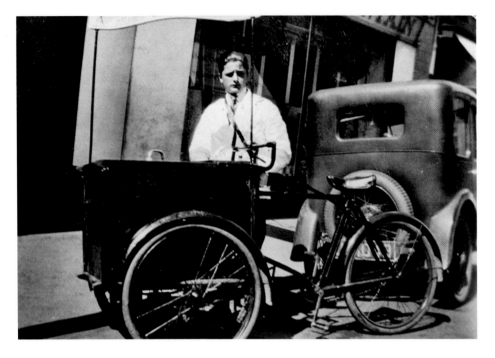

Ice-Cream Tricycle
This Ice-Cream Tricycle was used by Tony Macari in the town in the late '30s from which he would sell ice-cream. The ice-cream would be kept cold with ice surrounding the canister. The slightly more modern version is still owned by the family and used by Phillip to offer a service for champagne for events such as weddings – seen here at the wedding of Kirsty Wilson and Jamie Houghton in the gardens of Old Gala House in 2010.

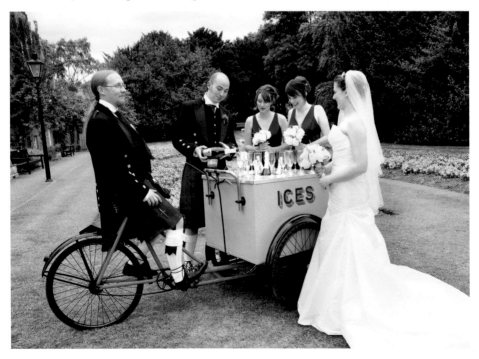

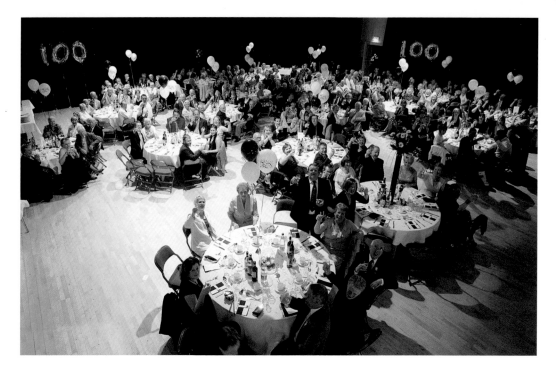

Galashiels Amateur Operatic Society

Galashiels Amateur Operatic Society members past and present celebrating 100 years of the society at a dinner in The Volunteer Hall, 1907–2007. A colourful cast pose in 1998 in the Burgh School at rehearsals, prior to their production of *Singing in The Rain* in the Volunteer Hall.

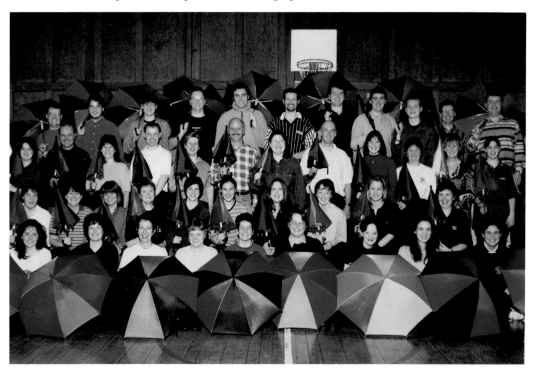

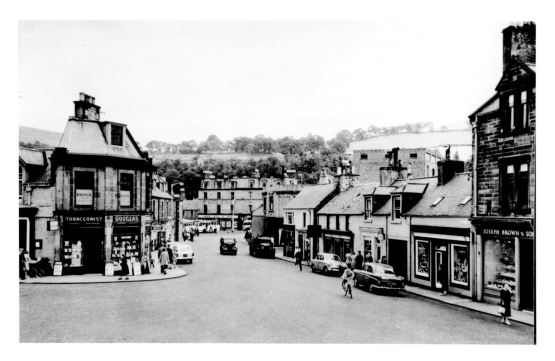

The Old Bus Stance

The old bus stance in Market Square at the bottom of Channel Street can be made out in this image taken in the late '50s. Older image shows a Brooke & Company vehicle and workers, from Albert Place. The company is recorded in 1923, by then Brooke and Amos, as starting a service between Galashiels and St. Boswells for a fare of 6d. They were taken over by SMT in 1926. Following this SMT started the first direct bus service to Edinburgh in 1927, from Galashiels.

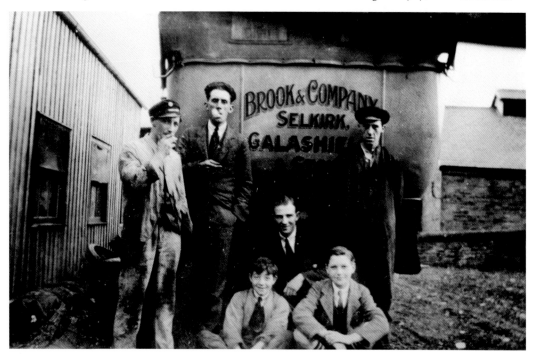

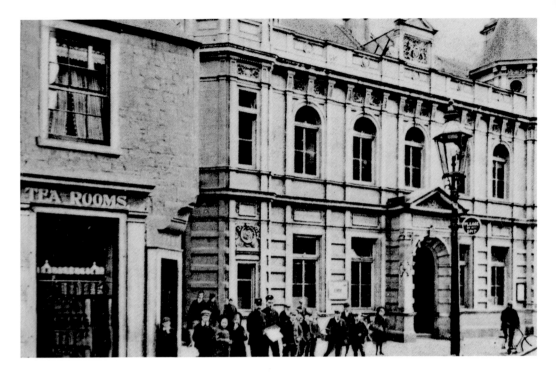

The Post Office
The main post office, a very grand building in the town, was built in 1896. It closed in 2007 when it relocated to the WHSmith store in Channel Street. Image *c.* 1909, in close up, shows a round sign on the lamppost with the words 'please do not spit'! Opening hours, mid forties are recorded as 8.30am-7pm, Sunday 9-10am, with five additional sub post offices in Buckholmside, Galapark, King Street, Huddersfield Street and Tweed Road.

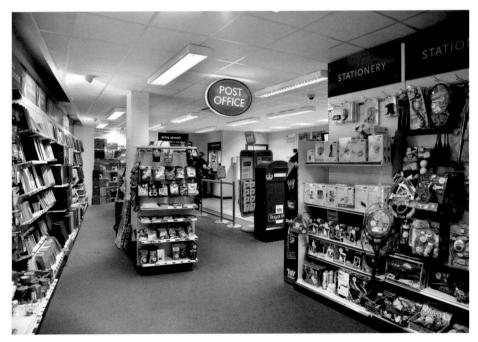

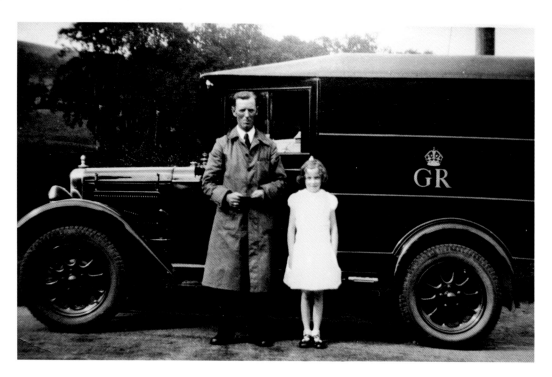

Postmen

Postman in the town, Alex Ruddiman, pictured in 1929, with his daughter Anne beside his post van. Anne years later owned the very popular sweet shop in the town's Market Street. In contrast Bruce Robertson got more than he bargained for when he delivered a parcel to me and was requested to pose for a photograph beside his 2010 post van in Roberts Court!

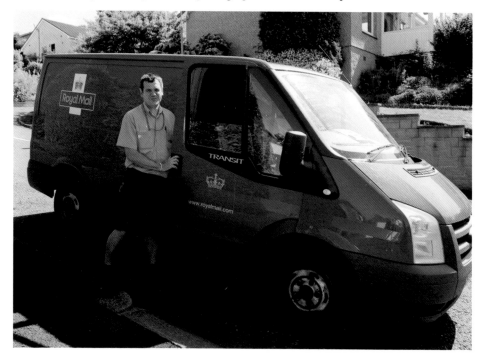

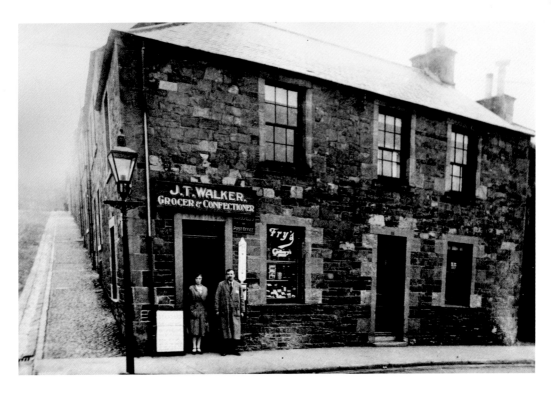

Huddersfield Street Post Office
Huddersfield Street Post Office, Grocer and Confectioner – mid to late '20s. This image shows Sub-Postmaster James Walker with his assistant Margaret Gordon. This property and others were demolished to be replaced with flats.

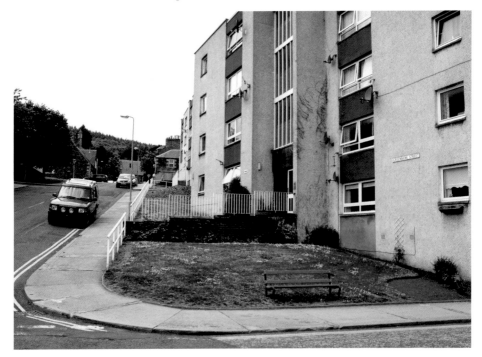

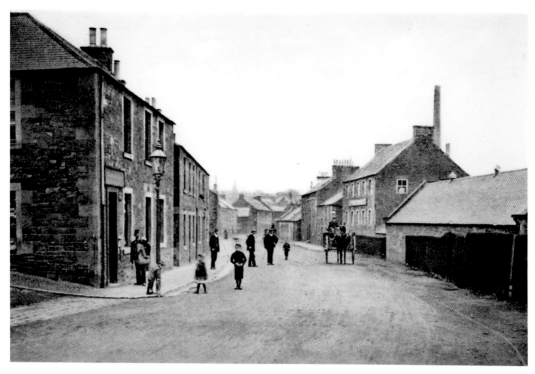

Huddersfield Street looking West

Huddersfield Street looking west *c.* 1906. The new image shows no trace of the sub post office on the corner left. On the right was Peter Anderson's Tweed Mill, Aimers McLean Iron founders, Waverley Iron Works, Pooley and Son Weighing Machine Repairers. At the far end, on the left, was Millers Laundry and also numerous wool merchants, yarn agents and worsted spinners.

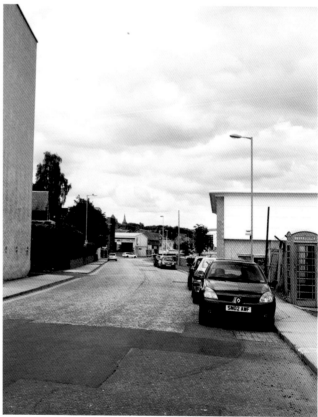

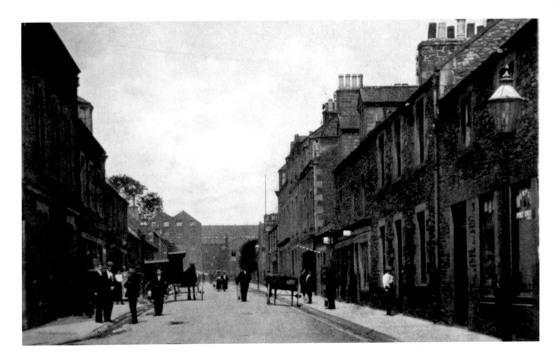

Island Street

Alex Dalgetty & Sons can be seen in the old image, where the bjaker's horse and cart stand on the left. The original bakery was in Galapark and moved to Island Street in the early 1900s. This is still a family business. Craig Murray, great, great grandson of Alexander Dalgetty, is seen in the new image in the bakery. The ovens still in use are over 100 years old.

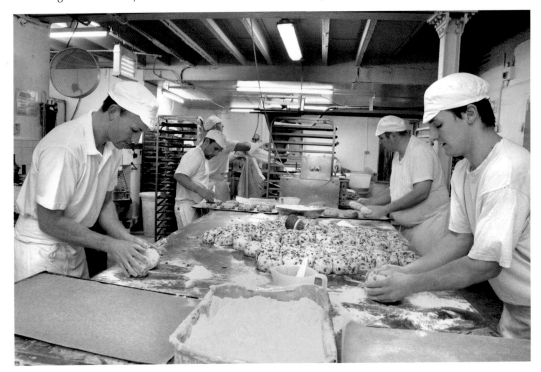

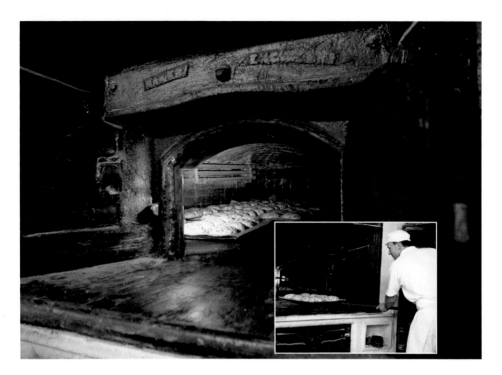

The Selkirk Bannock

Next door we see Michael Moore's constituency office. He became the first backbencher in living memory to go straight to Cabinet Minister in 2010 when he was appointed Secretary of State for Scotland. One of his first duties was to host a reception at Dover House in London for 100 dignitaries, for which he ordered six large Selkirk Bannocks from Dalgetty's to serve to the guests. Craig Murray seen here on the left making Selkirk Bannocks at 4.30am using his great, great grandfather's recipe.

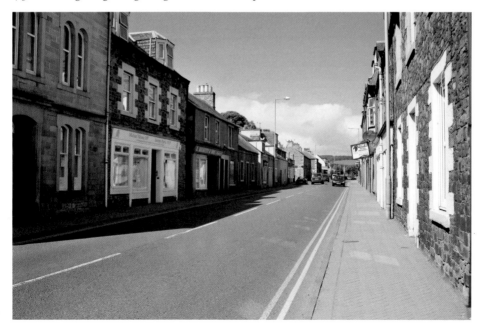

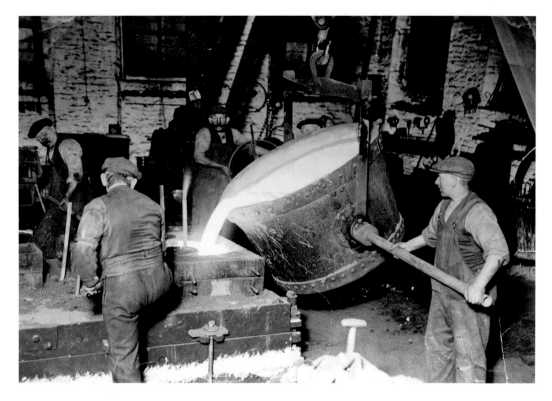

Aimers McLean Ironfounders
The top image shows brothers Andrew, Johnny and Walter Baillie at work with Aimers McLean
Ironfounders. The all-male workforce lined up below for the photographer (pre First World War).

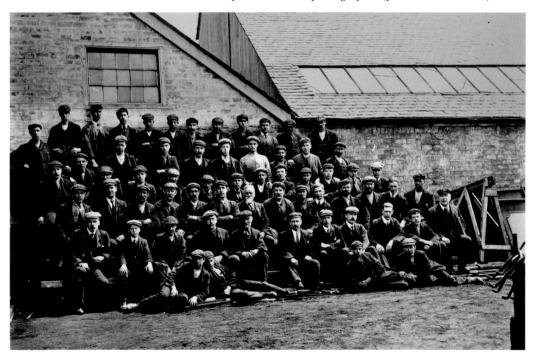

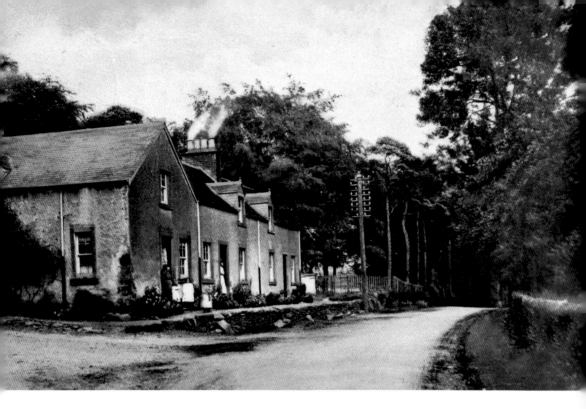

Melrose Road

The last houses in Melrose Road, on the outskirts of the town, remain virtually unchanged as does the direction of the road on the left leading to Lauder.

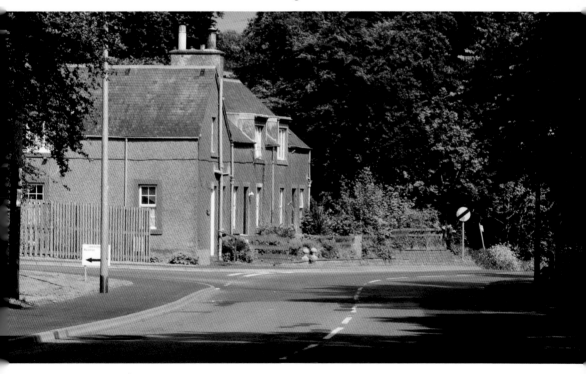

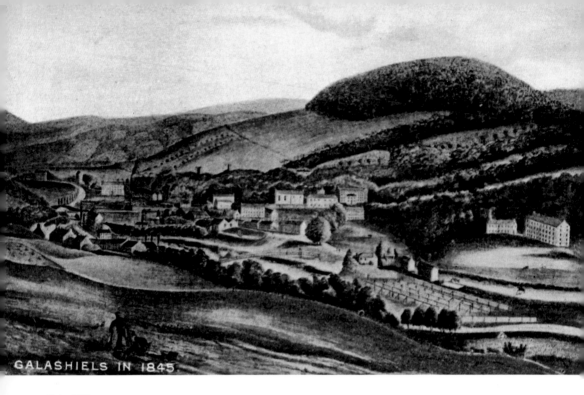

GALASHIELS IN 1845

Gala Hill

Looking toward Gala Hill, this early engraving is quite a contrast to the Galashiels we know today – Gala Hill being the only familiar sight. The foreground shows wooden 'tenters' where the cloth would be hung on hooks overnight (tenterhooks).

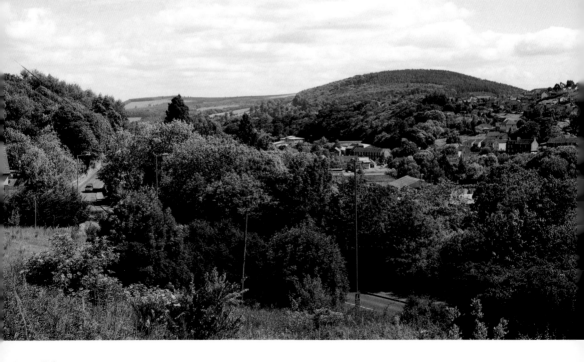

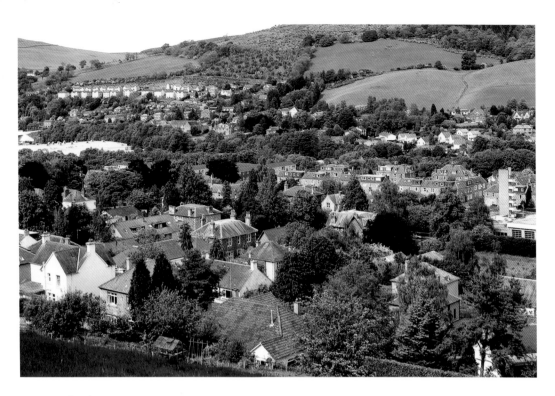

Oatlands Terrace
This view was taken from Gala Hill, just above Oatlands Terrace. Note the increase in housing development, especially toward the Ellwyn Terrace, Wylies Brae and Ladhope areas of the town.

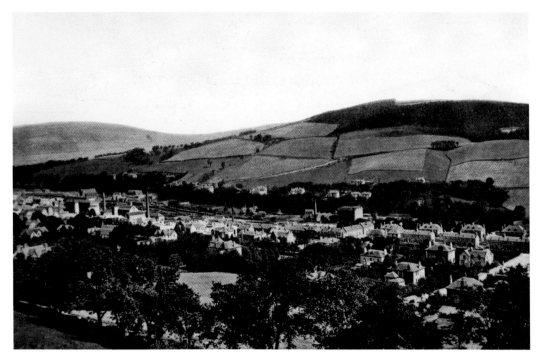

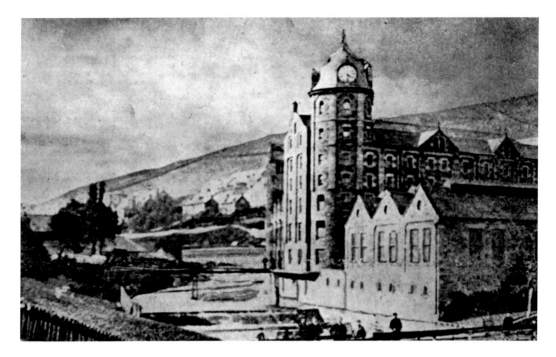

Sanderson and Murray

Founded in 1844 as a Fellmongers and Wool merchants in Wilderhaugh, Galashiels. The business suffered three fires during its time, rising from the ashes on each occasion – 1873, 1882 and 1923. The old image here shows the Clock Tower which was never rebuilt after one fire. There is no longer any sign of the skinworks which at its peak, would employ around 300 people. All that is left are the offices, now occupied by Cameron Architects.

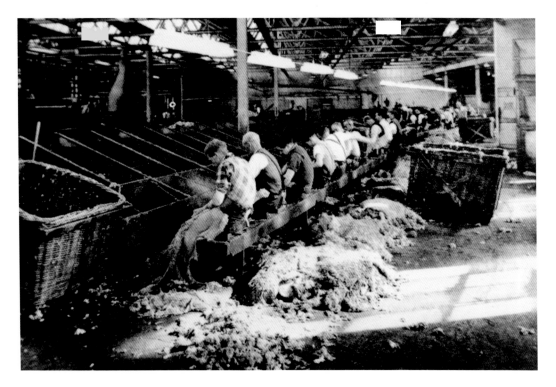

At Work
Workers are pictured 'pulling and grading' the sheepskins. Inset Dr. Edwin Winton, who arrived around 1947 as Chief Chemist and was a Director of the company until its closure in 1981.

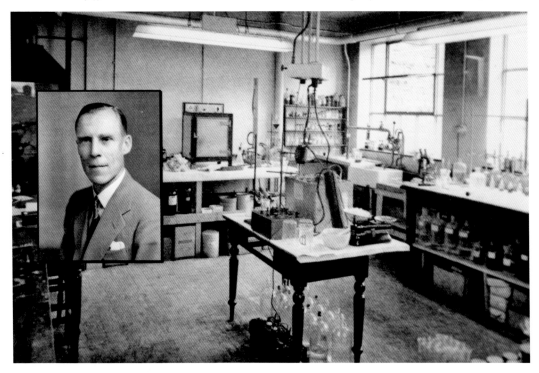

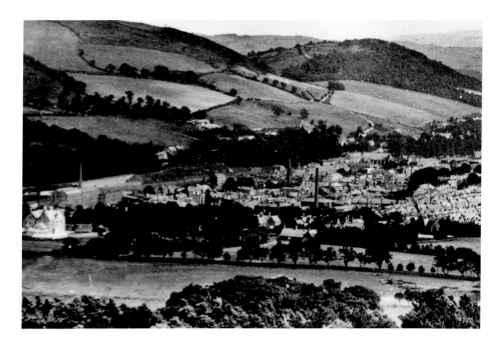

Galashiels in History

Views have been difficult to copy exactly due to extensive growth in trees, but photographing from the hills on the outskirts in 2010 leaves me feeling we are privileged to have such a beautiful setting in which to live. Ex Provost Rutherford makes reference in his book in 1930, *Galashiels in History*, to 'the great primeval forest' 'appearing in recorded history in the days of the Romans, and being described by Roman writers as vast and dense.' This density we again have of trees is the compensation for the vision of the white roofed, bland buildings which have appeared in the last ten years.

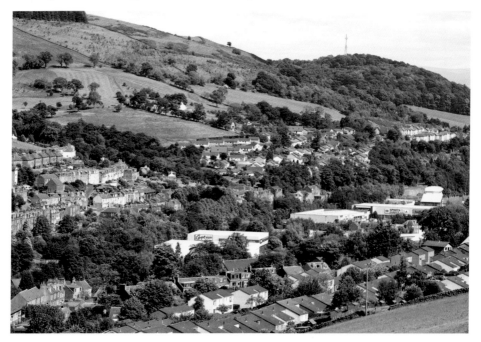

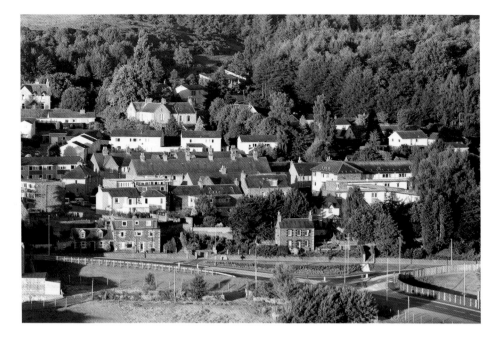

The Bow Butts

Below – View from The Bow Butts in 2010. Image looks over to Albert Place down to Huddersfield Street and up on the hillside to Ellwyn Terrace and Ladhope areas. The Bow Butt steps got their name from the first quarter of the seventeenth century when villagers over twelve and under sixty 'found opportunity for practice with bow and arrow on Sabbath afternoons at the conclusion of church service'. The Bow Butts was also the site of Logan's stables in the late 1800's, where corporation carts and pigs were kept. The other image is taken from the opposite side of the town looking over to Albert Place.

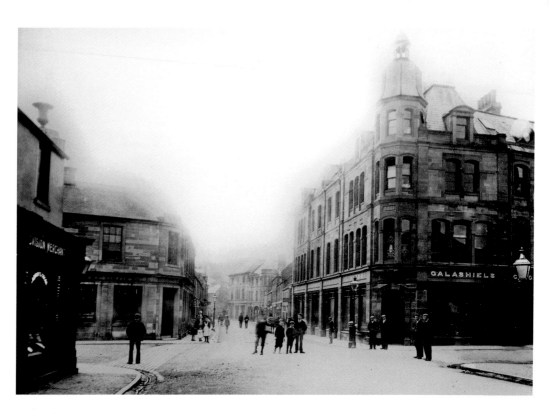

Island Street Junction

Junction of Island Street and High Street is a part of the town centre having a similar layout as it did in the 1890s. What was the old Royal Bank can be seen on the left hand side – latterly The Golden Lion – now unoccupied. Now we have a one-way system up High Street to the junction with Island Street. The premises on the left in the new image is occupied by The Bridge Inn and to the right Murray and Burrell.

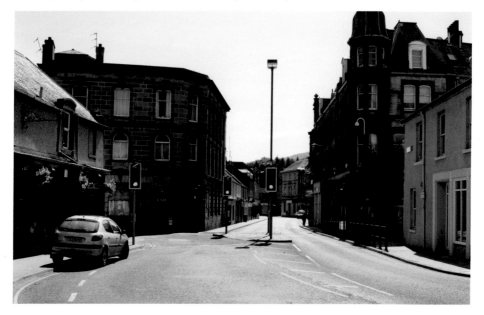

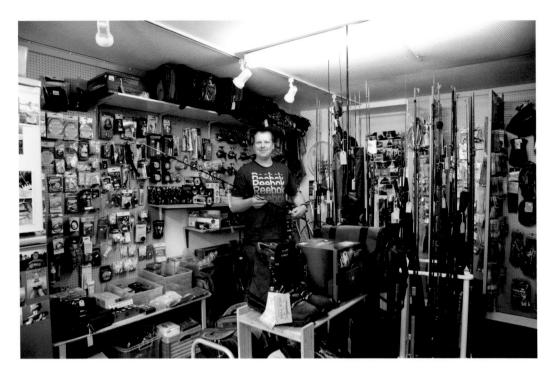

The High Street

Further down High Street the old photograph shows John Thomson who operated a saddler's business at No. 97 c. 1930s. There are no saddlers working in the town now, and having taken many forms over the years, this shop is now run by Mike Allan of The Border Angling Centre. Back in 1946 the Almanac and Directory published by John McQueen and Son record two saddlers and four fishing tackle makers in Galashiels.

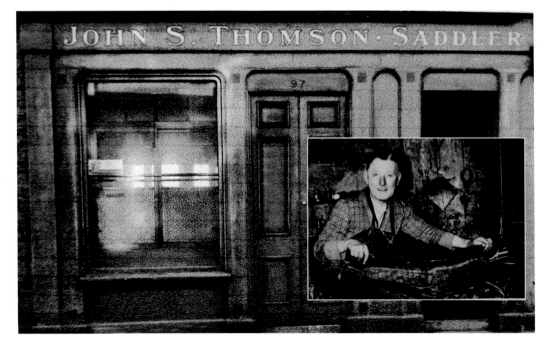

Station Brae Demolition
Station Brae demolition in
2006 with the more recent
image showing the finished
new road layout at the
Catholic Church.

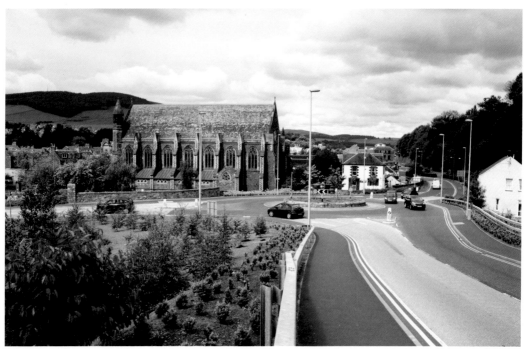

Station Brae

The Station Brae, old and new, with the Health Centre in the foreground. The mills and old Station Brae (seen in the older image) having gone, the view now shows the roofs of the new shopping complex built around the Huddersfield Street area.

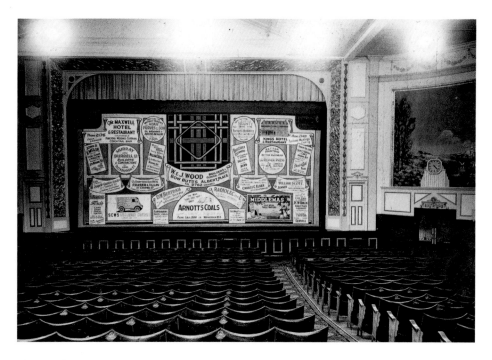

The Pavilion

'The Piv' (The Pavilion) in Channel Street, home to cinema and other productions, was demolished in 1970. This image was taken after the new proscenium was added along with the extension of seating etc to the right hand side (1930s). Below the interior of The Playhouse, which was situated further down at the bottom end of Channel Street and opened in 1920. This building is a cinema and bingo complex but now uses the name 'The Pavilion'.

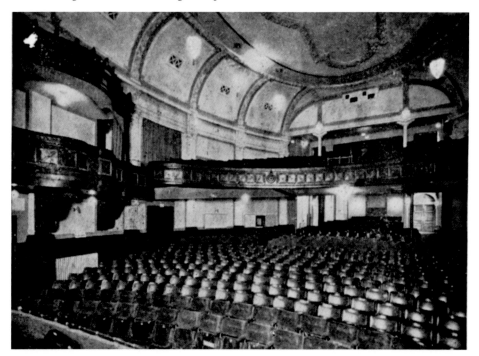

Fraser & Allin

The fire curtain seen on the previous page in 'The Piv' is a sad reminder that only a few of the businesses remain. One however is Fraser & Allin, whose premises are seen in the picture at 67 Channel Street (previously 25 Island Street). Jim Fraser and John Allin met in the trenches during the First World War and said if they survived they would start in business. Owner today, Jim Lees (pictured) runs the business from Bank Street. He joined his father as an apprentice in 1960, later taking over from him in 1972.

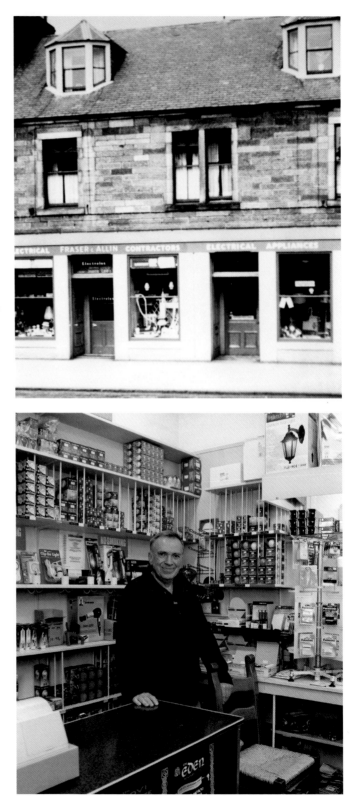

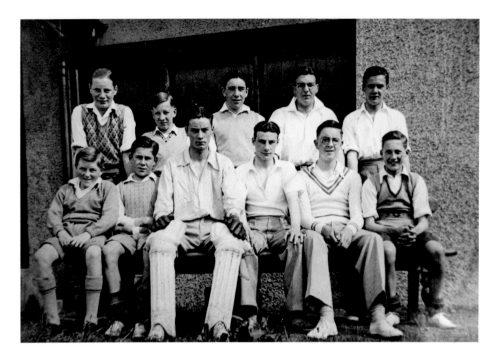

Gala Cricket Club

Gala Cricket Club was founded in 1853, having moved in 1900 to the foot of Meigle Hill. A very successful and popular club, and winners of the Borders League again in 2010, they currently train up to fifty youths on a Saturday. Gala Academy Team in 1938, with the new image of some of the 2010 players. The new shirts, presently worn by the team, have 'Rowan' on them as a mark of respect for Rowan Bowland, a talented youngster who had tragically collapsed and died at the club.

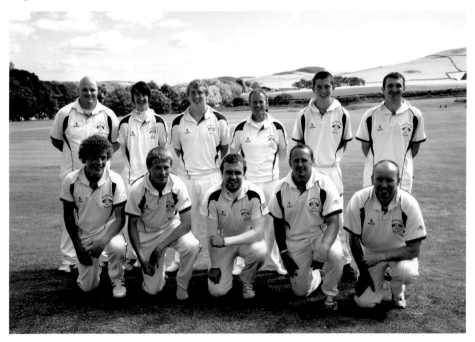

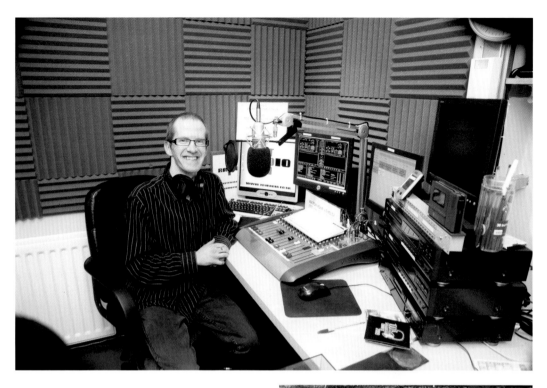

Changes

The image of Bert Clark and George Goodfellow who were apprentice electricians with Alexander Aitchison in Albert Place in the early thirties. Inset, the two dental practitioners Frances Munro and James Thom, who occupy the premises today. There is an advert in the window for a Melophone receiver and speakers – £12.10s.-d. Today's technology allows David Henderson to turn his bedroom, in his Victoria Street house, into a radio station, broadcasting 'TD1 Radio' to listeners over the internet.

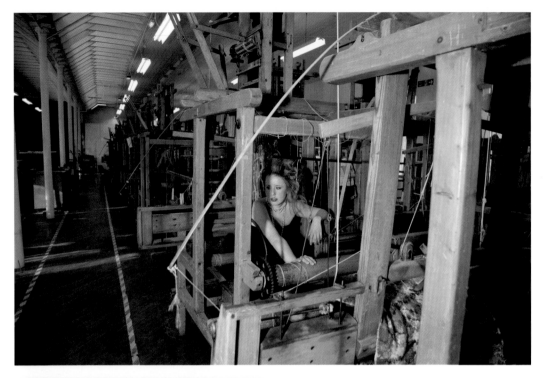

Looms

Although the woollen and textiles industries have seen a drastic decline, looms can still be seen in the town. The image of the young student was for a fundraising calendar and was taken within Heriot Watt University at the end of 2009. The other image shows the last remaining mill chimney in the town at Schofield, Dyers and Cloth Finishers in Huddersfield Street.

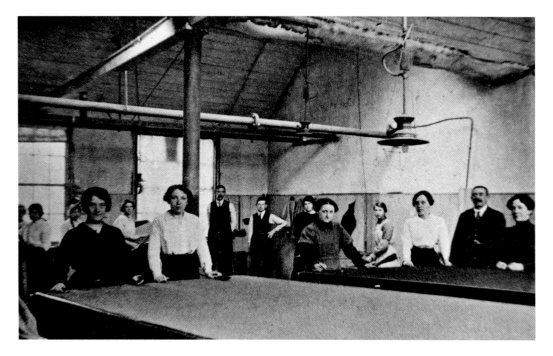

Workers

My grandmother, second from the left, a darner in Botany Mill in the early 1900s. Also a group of ladies from Ovens Mill's Darning Dept. pose for a group photograph in the early 1920s. One tradition amongst the millworkers in years gone by was to get a coat or jacket belonging to a ' bride-to-be' and decorate it with small household items and hang it outside the mill where she worked. Later she would wear it home.

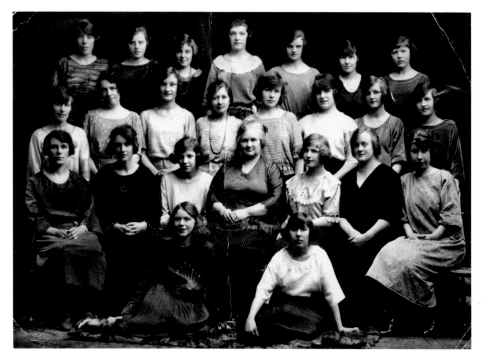

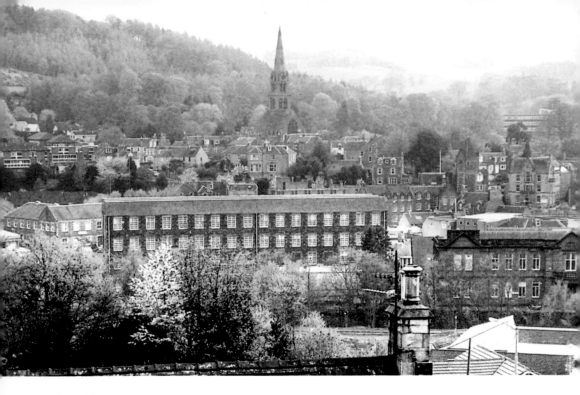

Valley Mill
Valley Mill, and at the moment of demolition in 2004 to make way for the new shopping centre in the town.

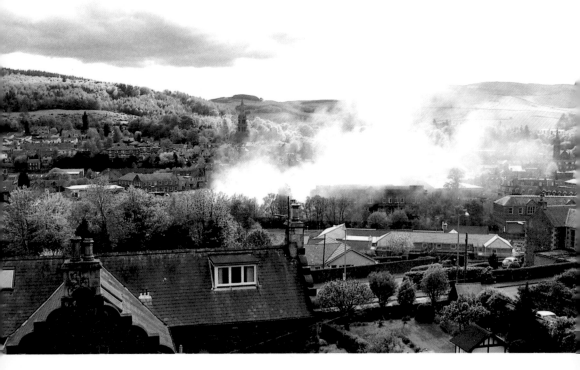

Mill Drawings

An old, empty 'flat' within the mill uncovered some interesting drawings and signatures on the walls.

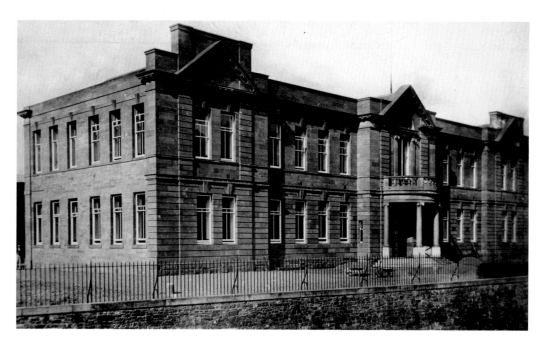

South of Scotland Technical College

Built in 1909 for a cost of £24,000, this was the South of Scotland Technical College. The building, prior to demolition in 2006, was used by the Department of Health and Social Security. Tesco, who had purchased the site, agreed to dismantle the stonework bit by bit and store it to be used on a future project within the area. This was a means of compromise for locals who had objected to the demolition of such a fine building.

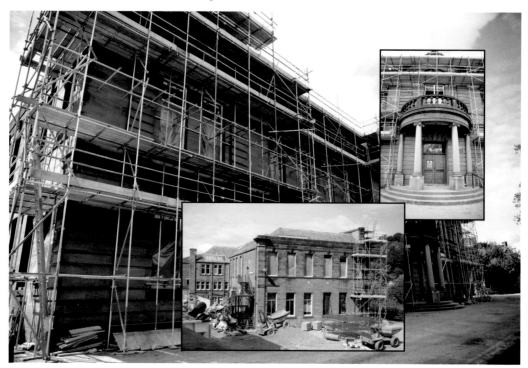

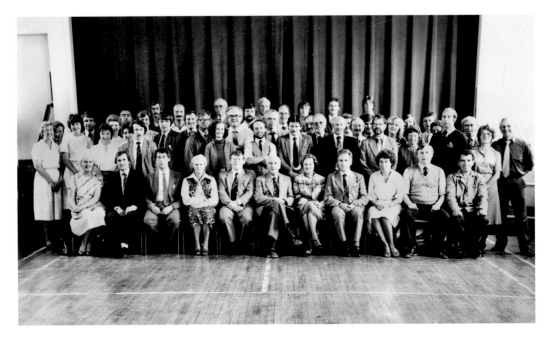

Borders College

In 2009 Borders College moved from Melrose Road to within the Heriot Watt University Campus at Netherdale. This is a great facility in the town. The old image shows staff and lecturers in the early 1980s. The new image shows Principal Liz McIntyre with her staff outside the recently renovated campus building.

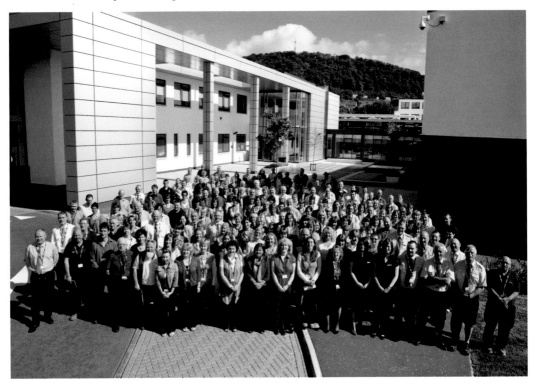

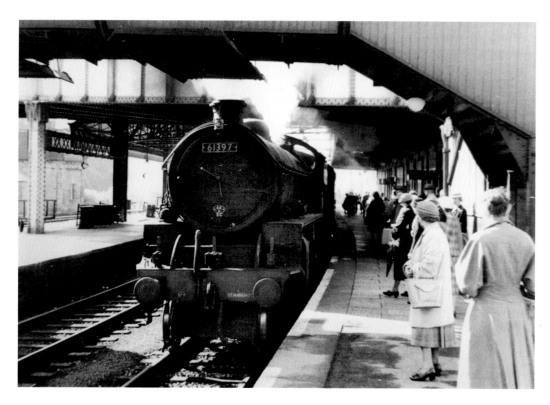

Railway Station

Gala travellers wait to board the 61397 morning train to Edinburgh (Class B1 4-6-0 St Margaret's)
The no. 62 bus for Edinburgh today comes along the route as the train would have departed the
station, passing The Abbotsford Hotel. The station opened in 1849 and closed in 1969.

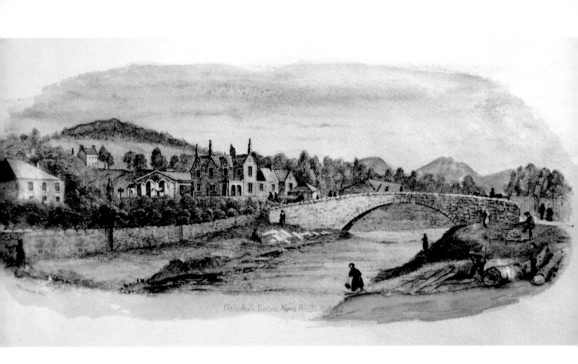

Galashiels Station

This scene titled – 'Galashiels Station, North British Rail', shows women washing clothes by the river with the railway station buildings to the left. In 1917 the cost of the fare to Edinburgh was put up from 1d to 1½d a mile (old currency) 'as the train had got faster'. The train seen in the photograph has, unusually, two engines which suggests it was carrying a heavy load.

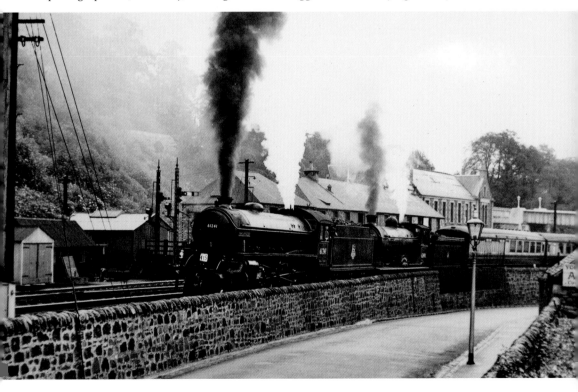

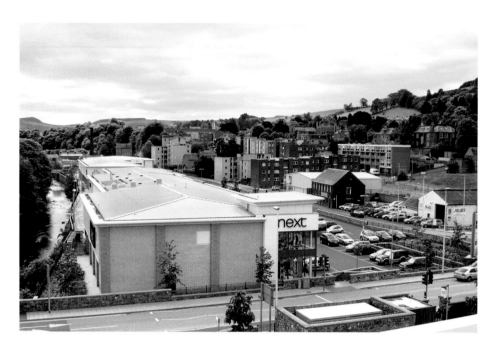

George Craig

Locharron of Scotland's mill building in Huddersfield Street, being demolished in 2006, having moved their head office and weaving production to Selkirk. The new road crosses the George Craig Bridge. George Craig (1783-1843) was a lawyer and agent of The Edinburgh & Leith Banking Co, the first bank to be established in the town. Situated in Elm Row, it failed in 1842. While out hunting with Sir Walter Scott one day Mr Craig was accidentally hurt. This was part of Sir Walter Scott's account of the incident; "Queen Mab, lifted up her heels against Mr Craig, whose leg she greeted with a thump like a pistol shot. Mr Craig would not permit his boot to be drawn off, protesting he would faint. Some thought he was reluctant to exhibit his legs in their primitive and unclothed simplicity, in respect they have an unhappy resemblance to a pair of tongs".

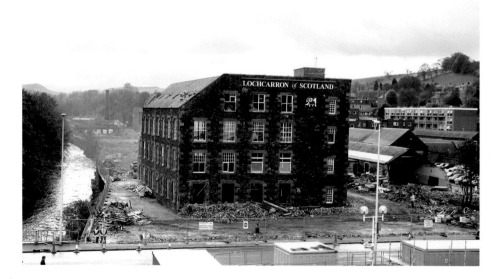

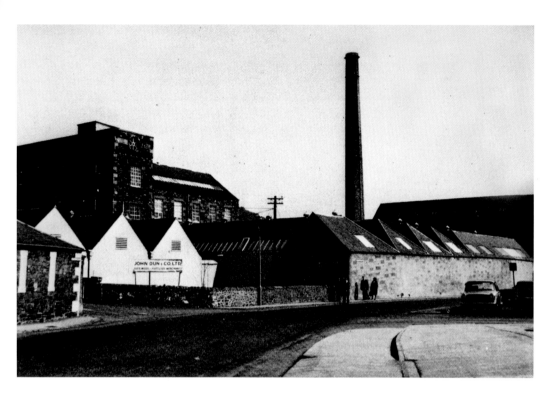

John Dun & Co.
The premises of John Dun & Co., Huddersfield Street, (*c.* 1960s) now demolished and where the popular High Street stores have now located. To the right on the roundabout – once the entrance to the Burgh Yard – a road gently climbs to join the Abbotsford Road in Albert Place, now known as Braw Lads' Brae.

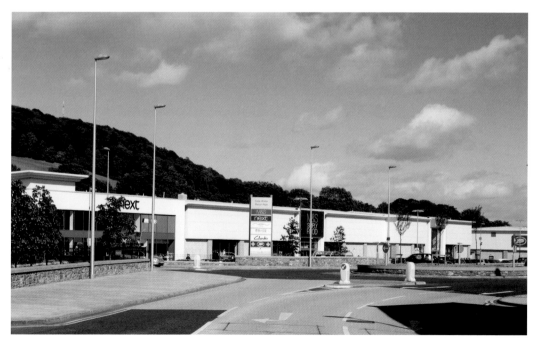

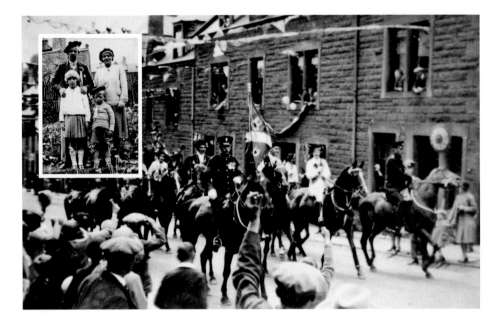

Braw Lads' Day

Burgh Police Sergeant Waugh was the last mounted police officer the town had. He is seen here riding on the first ever Braw Lads' Day in Scott Street in 1930. Today the police mounted section is based in Edinburgh. PC Karen Scott (left) and PC Nikki Halliday are seen in Scott Street (2010), checking the road is clear for the main cavalcade. Karen herself had been Braw Lass in 2000 and celebrated this, her tenth anniversary on duty. Inset image shows how my grandparents, mother and uncle dressed in preparation for the first ever Braw Lads' Day.

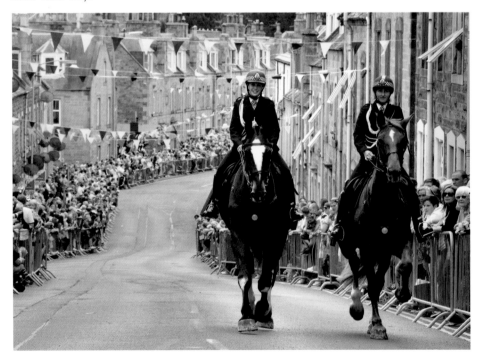

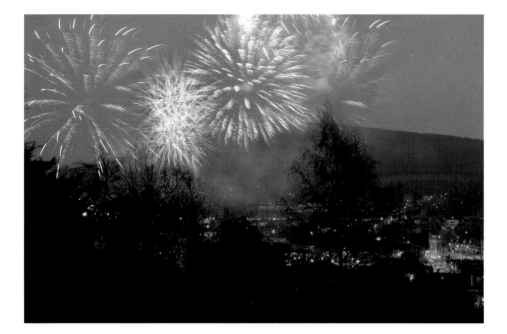

Braw Lads' Gathering

Few things have changed over the years of the Braw Lads' Gathering, but additions such as the fireworks display over the Burgh Chambers in April to announce the new Braw Lad and Lass is one which attracts the crowds. Another is The Big Breakfast. Richie Gray (great grandson of George H. Tait – page 84), and friends used to gather for breakfast in the 1990s prior to the Braw Lad receiving the flag. Now Richie organises this same breakfast for approx 300 in the Volunteer Hall. Each person attending is expected to wear the Braw Lads' tie and in recent years the Braw Lad, Lass and Principals have made a short appearance where they get a great reception to start off their day. Inset 2010 Braw Lad and Lass.

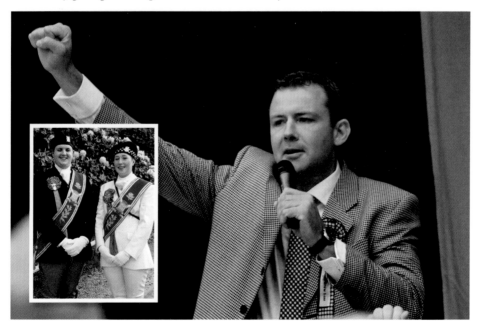

Only Fools Nae Horses

Soon after the Braw Lad and Lass were elected in 2001, the ceremonies involving horses were cancelled due to Foot and Mouth Disease. The top image shows the activities which had been arranged in the Scott Park in place of Braw Lads' Day, and below the six principals from 2001, unable to ride to Torwoodlee, took part in the Fancy Dress Parade using the idea from a popular TV series and entering as 'Only Fools Nae Horses'!

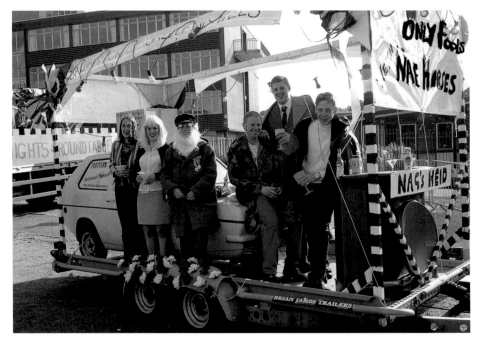

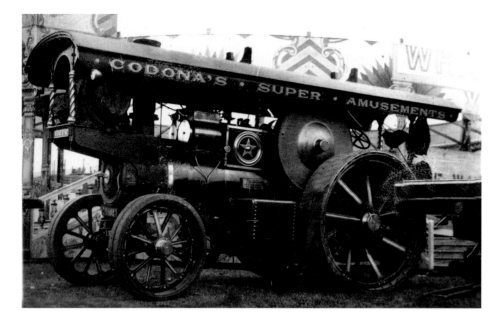

The Codona Family

Another little known custom of Braw Lads' Day is the visit to 'the shows' in the afternoon by the principals. Organised for many years now by Bill Lamb, the Codona family play host to the six principals. Since the start of the Gala Day in 1930, the Codona family take a lease for the park during Gala Week and have continued, each year since, to provide an excellent fun fair. The old image of the traction engine – *Rising Star* – was taken in the early years during one of the Codona family visits to the Gala Week. Sisters Margaret and Penny Codona can be seen wearing the black and white checked scarves and rosettes when they meet 2010 Braw Lass Katie Scott and Braw Lad Greg Borthwick. Other image shows Douglas Codona with friend Bill Lamb.

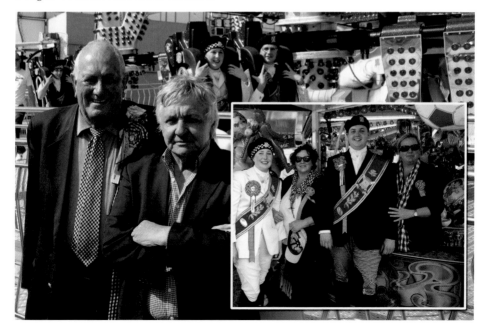

Graham Howlieson
In recent years a Chief Marshall has lead the principals and cavalcade on the Braw Lads' Day. Chief Marshall until 2009 was Graham Howlieson (Huggy), seen leading the cavalcade down Tweed Road in 2005, and also in his early years, less comfortable in the saddle in Balmoral Avenue!

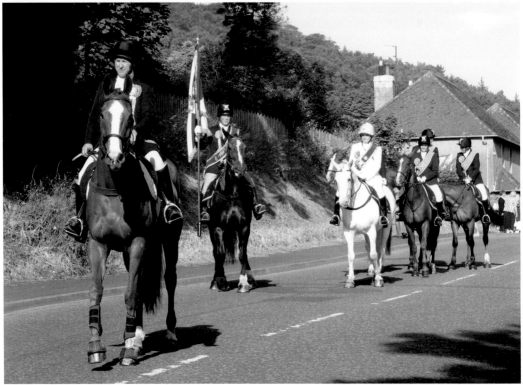

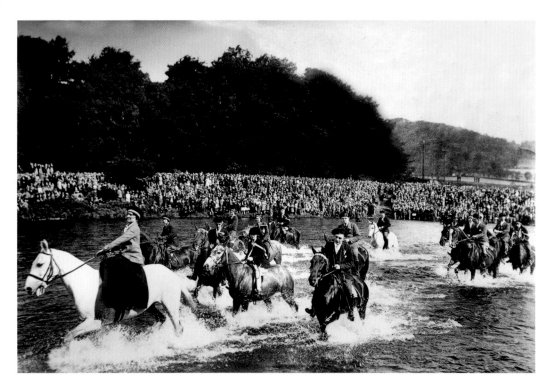

Horses Cross the Tweed

Horses cross the Tweed on a Gala Day with a lady in side saddle leading this group of riders. Below, taken from a popular viewpoint – the bridge over the river at Gala foot – the principals ford the tweed on their way to Abbotsford in 2010.

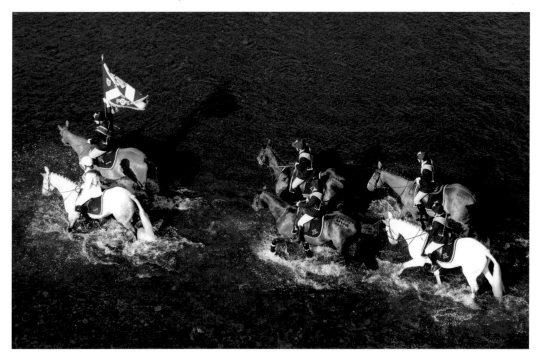

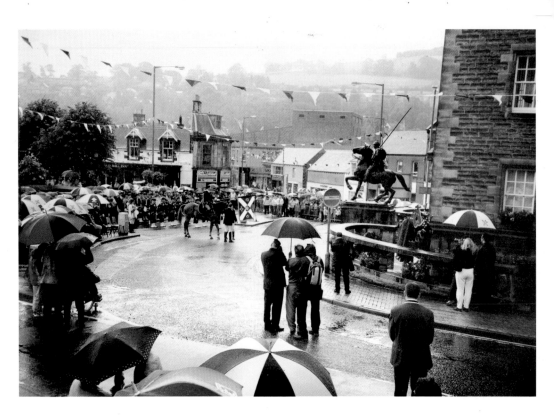

The War Memorial

What started as a lovely sunny day in 2004 ended with a deluge of rain. Ironically a new Gala Braw Lads' Umbrella had been launched and came in very handy for those in attendance at the War Memorial for the final act of homage. Below close up taken at night of The Reiver at The War Memorial.

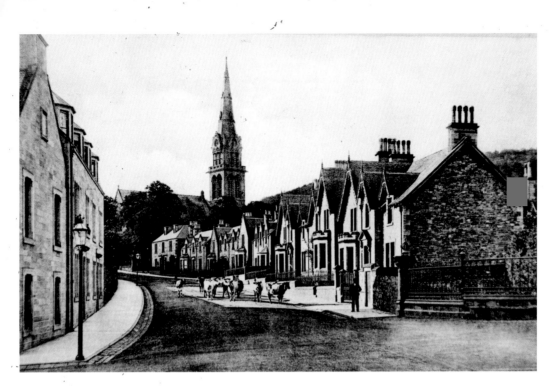

Scott Crescent

In the late 1800s the town had two dairies in Church Street; one belonging to Johnny Cunningham and the other Jock Anderson's. Cows are seen here coming down Scott Crescent, which would require a lot of thought and advanced planning if it were to be done these days.

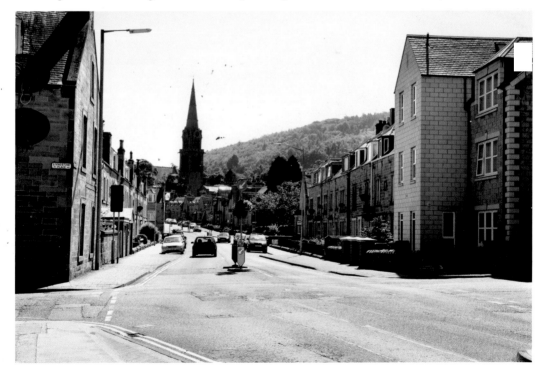

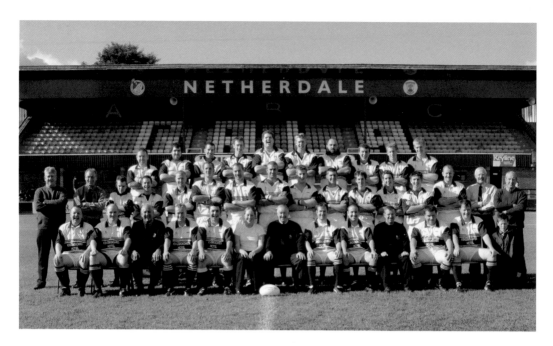

Galashiels Rugby

As with other Border towns Galashiels is well known for its rugby. Gala Juniors are pictured here in front of the Netherdale Stand in 2003. Below the photographer in 1987 capturing this young rugby team at Langlee would not have anticipated how successful these youngers would become. Eight went on to play for Gala RFC, one for Fairydean, one Scotland XV and Capt., one Scotland 7s Int. Capt., two Braw Lads and a Scotland XV Club Captain. It must also be noted that Chris Paterson (2nd from the right in front row) has recently gained his 100th cap for Scotland, an achievement of which the town is very proud.

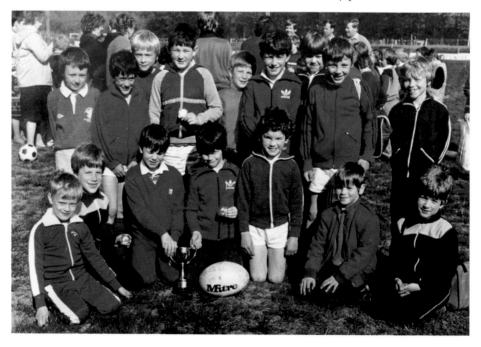

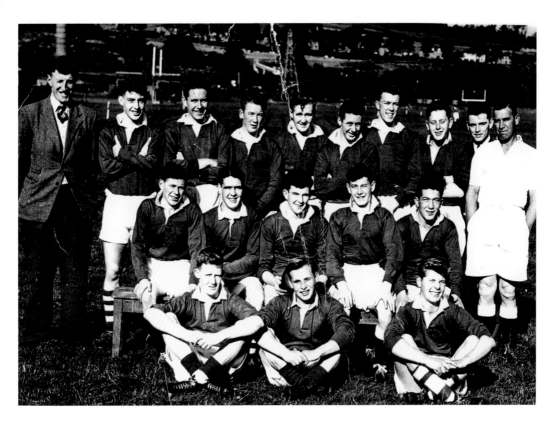

Gala Red Triangle Team

A Gala Red Triangle team of the 1950s era. Also 1st and 4th ward A teams in the under 10 section of Gala rugby boys 7s at Netherdale in 1961.

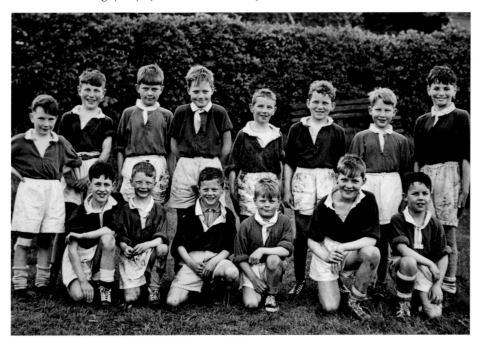

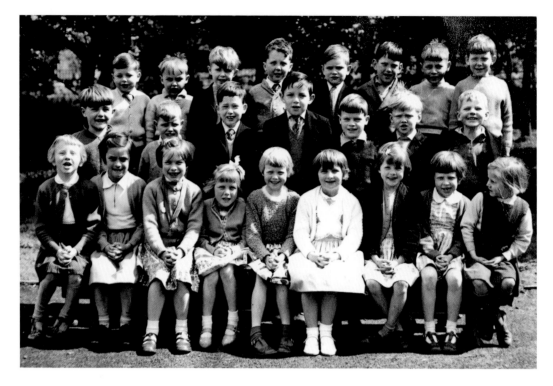

St Peters School

A St Peters School group taken in 1961, and another taken in 2008. My grandfather's memoirs recall the custom in the late 1800s of 'barring oot', when pupils stole the keys and locked the teachers out of the school, 'played the pug' up Gala Hill and then paid for it the next day with 'the tawse'.

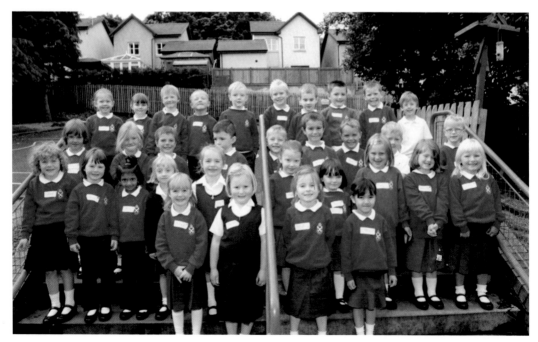

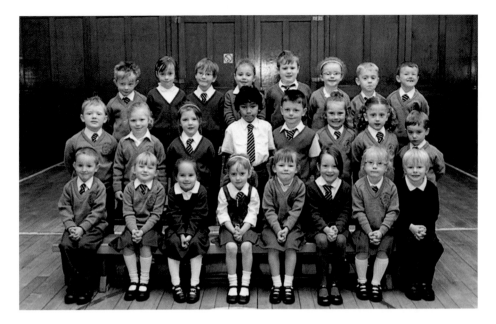

Burgh Primary School
Burgh Primary School group in 2009 and in 1954.

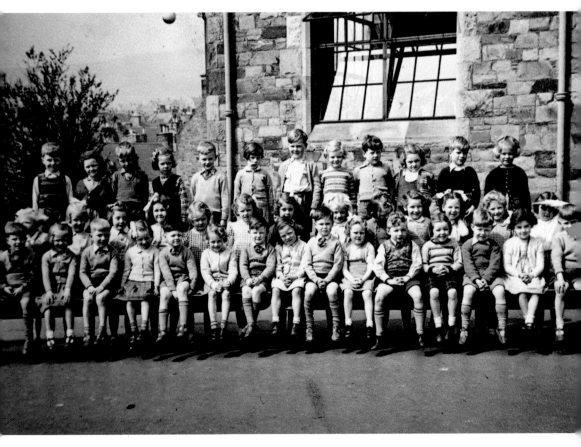

Gala Week Visits

It is customary for the Braw Lad and Lass to visit all the Galashiels schools during Gala Week. Braw Lass Marvyn Clark and Braw Lad Robson Reid are pictured in 1967 with a group of schoolchildren out to wish them well for the Gala Day. Image below – Glendinning Terrace School *c.* 1960.

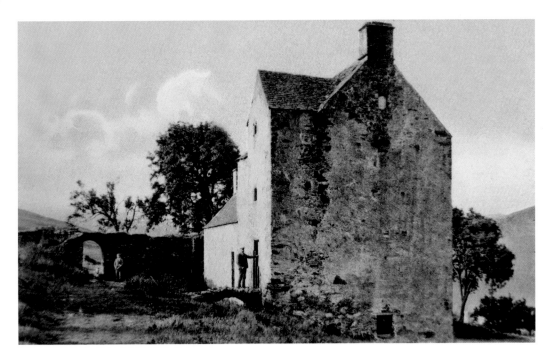

Buckholm Tower

Buckholm Tower was inhabited by one of the Pringles (persecutor of the Covenanters) who suspended his victims from hooks through their chins! Henry Davidson Minister 1714–1749 is reported to have put an end to his 'nightly wanderings' by visiting 'The Deil of Buckholm' and casting out the devil! Buckholm Tower pictured from Meigle Hill is now a ruin.

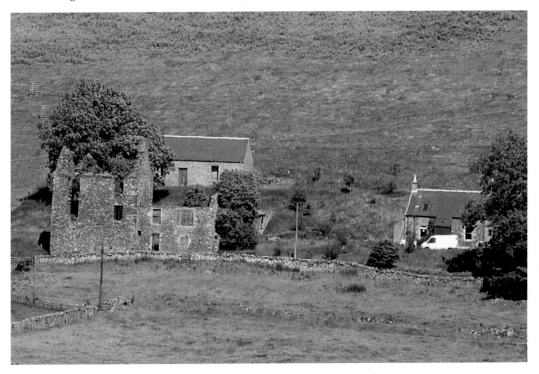

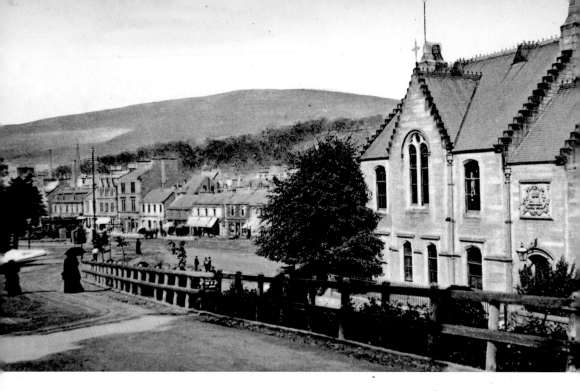

Burgh Chambers and Council Offices
The Burgh Chambers and council offices just in view on the right, with the clock tower a noticeable addition in the latest image. Old image *c.* 1912.

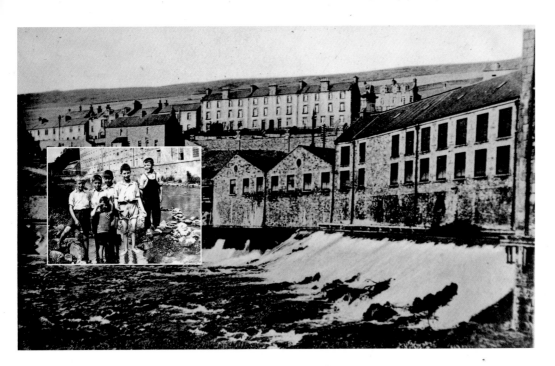

The Mill Laid

Situated in the Wilderhaugh area the Mill Laid is difficult to view as it was. The inset image shows young Sinclair Chalmers, James Davy, John Morrison, Jackie Kennedy, and Arthur and Ronnie Ballantyne in the late twenties having fun in the water. Not something parents these days would be able to encourage due to access and safety issues.

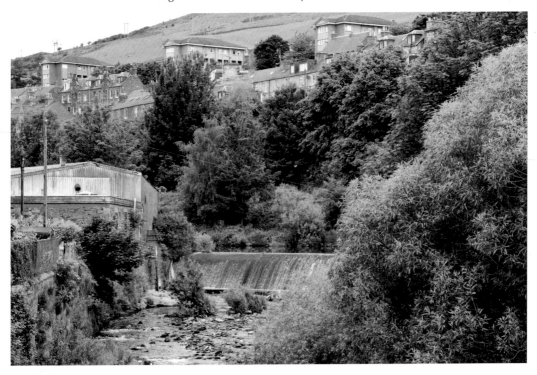

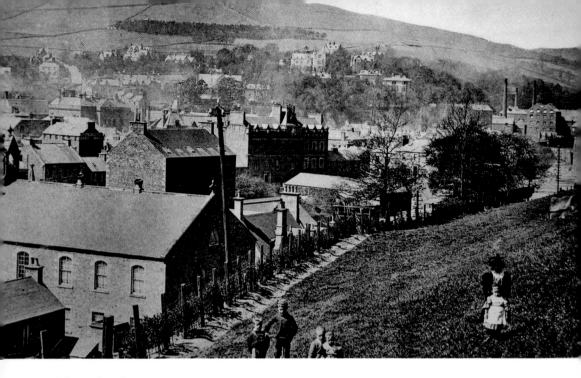

High Road Park
The High Road Park is still a popular place to walk or sit, despite the tree growth which now restricts the views over the town.

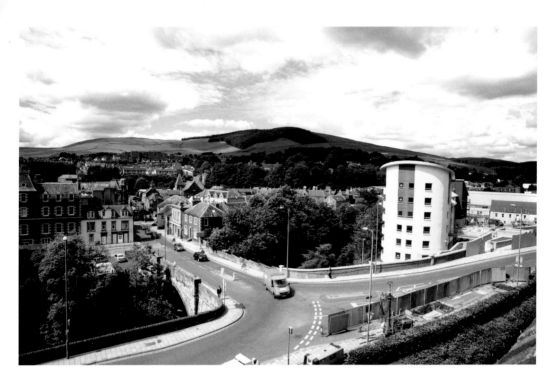

Fire at the Mill

This shot of a mill fire in 1928 shows the site of where Laidlaw & Fairgrieves Mill was recently demolished to make way for a new housing complex. This is now best viewed from the opposite direction, in the High Road. The spot where hundreds of onlookers can just be seen in the old image on the top right of the picture, lining the wall to view the fire in the mill.

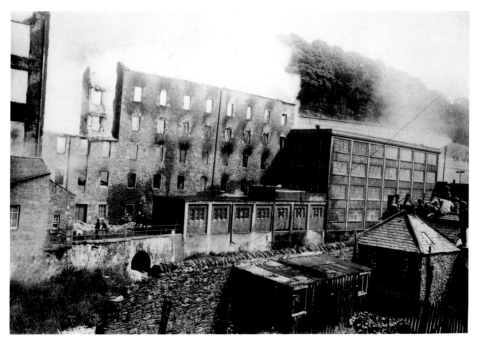

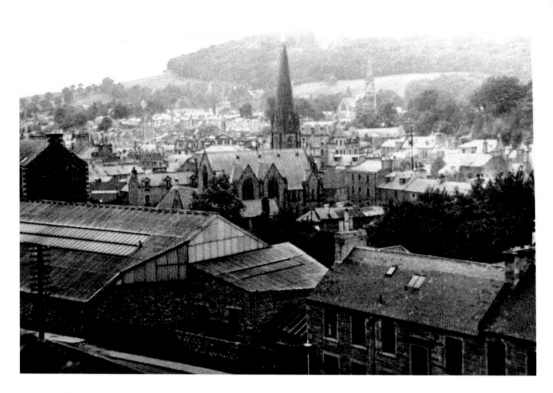

Ladhope Vale

Looking over from the High Road onto Ladhope Vale and in the distance to Gala Hill. In the old image the church spire of St. Andrews Church in Bridge Street can clearly be seen. This was removed in 1985.

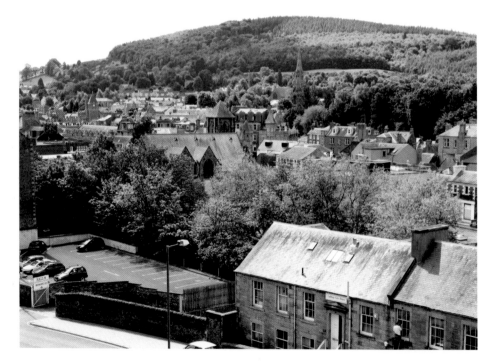

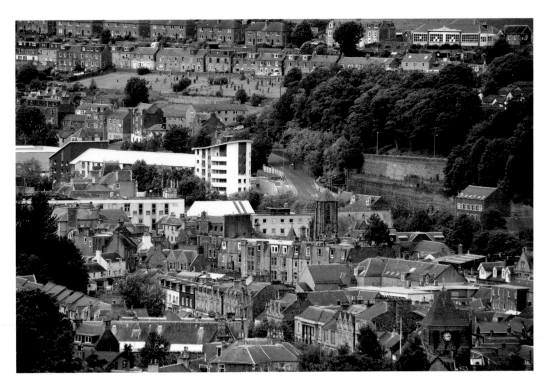

Ladhope Tunnel

In December 1916 the retaining walls at Ladhope Tunnel collapsed and had to be re-built. Workmen are shown here posing for the photographer on the steep embankment. The walls remain to this day and are used as a place to drop homemade 'birthday banners' from the High Road, inviting motorists to view their messages when heading to Edinburgh on the A7! The embankment and walls can be seen to the right of the picture just below the trees.

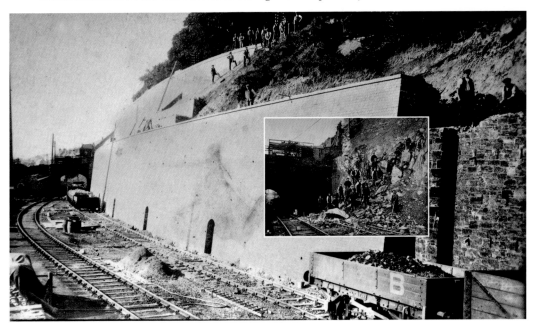

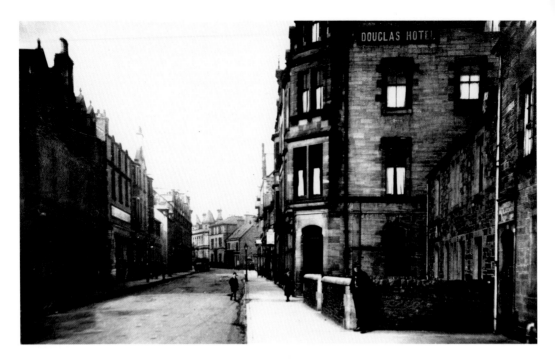

Channel Street

Four images showing the contrast in Channel Street. Noticable is the amount of 'For Sale' and 'To Let' signs in the street. Many of the small independent shops now find rates prohibitive in the town centre, on top of the the lack of trade in the recession present at the moment.

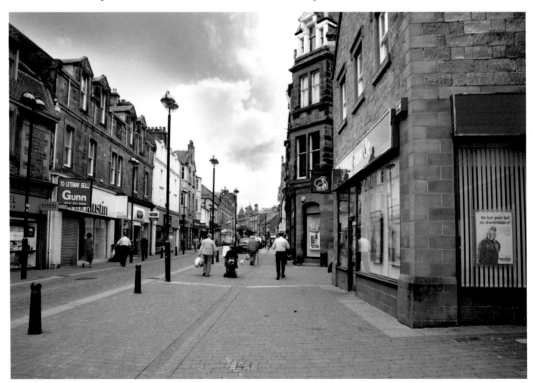

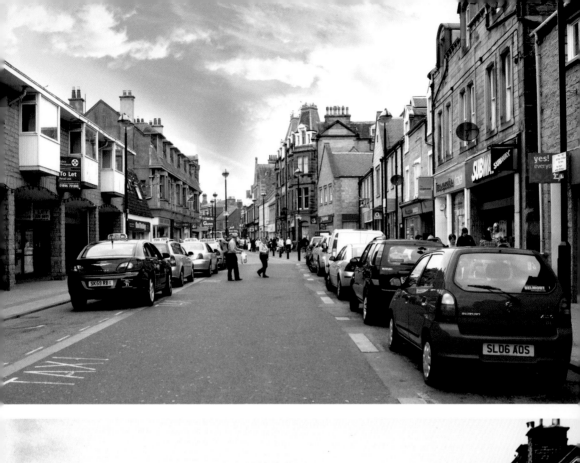

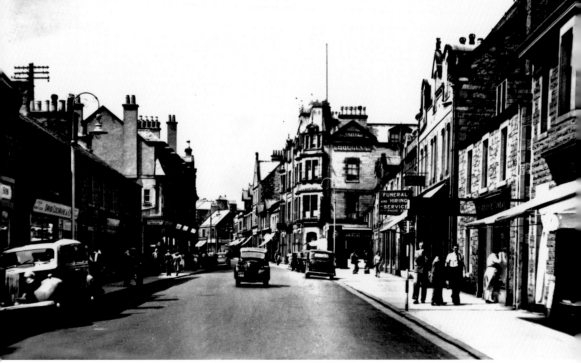

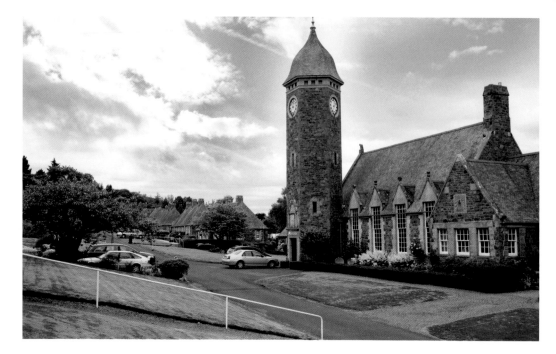

Lucy Sanderson Homes

A lovely residential area opened in 1933. James Sanderson and his wife Lucy had no children and when James died in 1927 he left funds for the building of sixteen semi-detached cottages for folk who had done good work in the town. The murals around the walls in the community hall were painted by William Rawson Lawson, who studied at Edinburgh College of Art under Robert Burns, and M. R. Caird, in 1936.

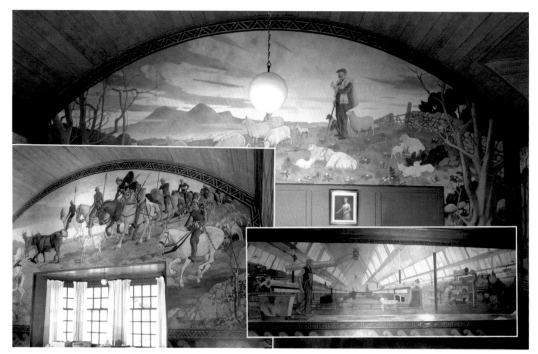

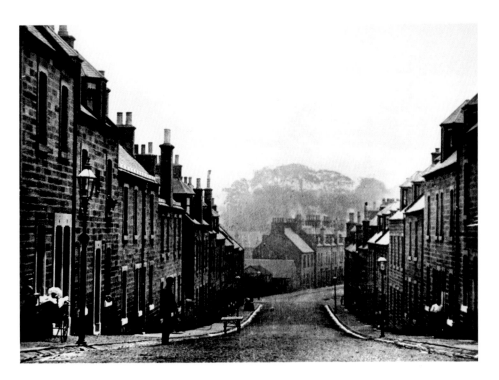

St Andrew Street

St Andrew Street, for a number of years, has been a popular area for first time house buyers. It is much busier in the way of traffic now and has satellite dishes aplenty!

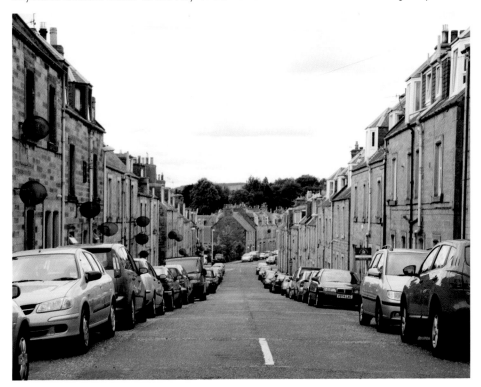

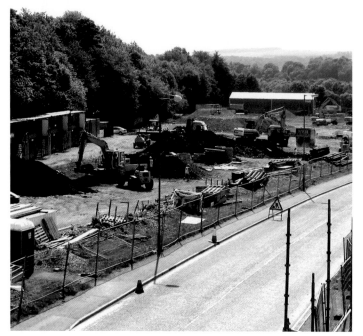

Curry Road
In 2006 work had begun to change the area known as Curry Road, changing the route of the road past the recently built Health Centre. Asda moved into Galashiels building a superstore and large car parking area to accommodate customers from all over the Scottish Borders area.

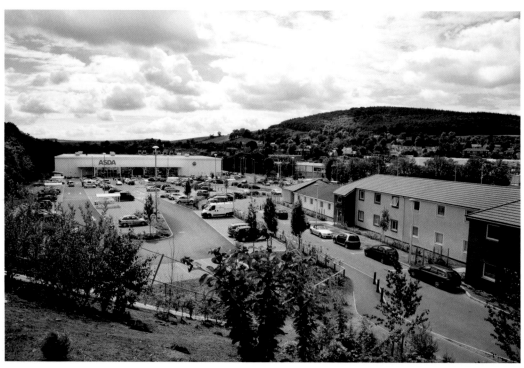

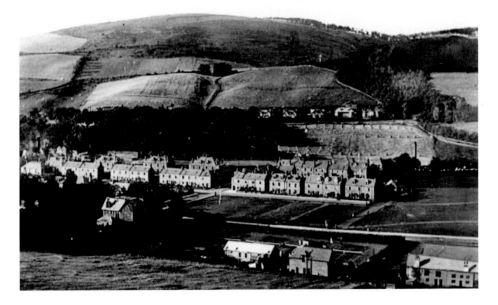

Fields and Houses

Looking over from Gala Hill long gone are the penny and twopenny putting greens and the fields are now filled with houses – now Glenfield and Langhaugh housing estates. The Fire Station, which opened in 1974, can be seen with its training tower in the new image. Robert Bros. Circus seen here visiting the public park in 2010.

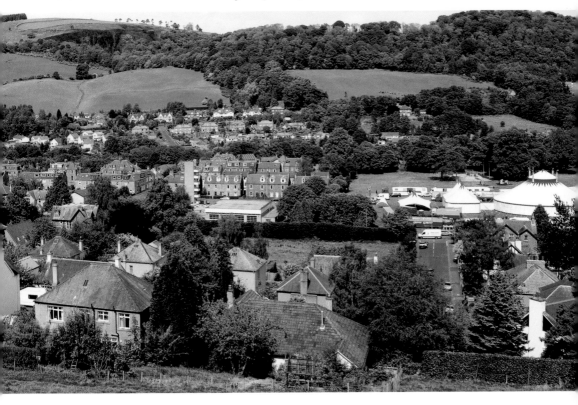

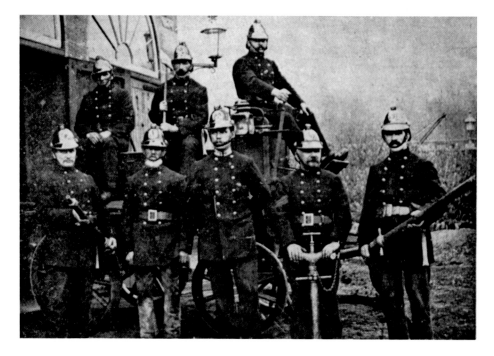

Galashiels Fire Crew

This photograph of an early Galashiels fire crew proudly displaying their equipment certainly is a contrast to the other image taken early 2000. Firemen Brian Aitchison and Bruce Swan demonstrate new personal equipment and protective suits which could be used at chemical and other major incidents.

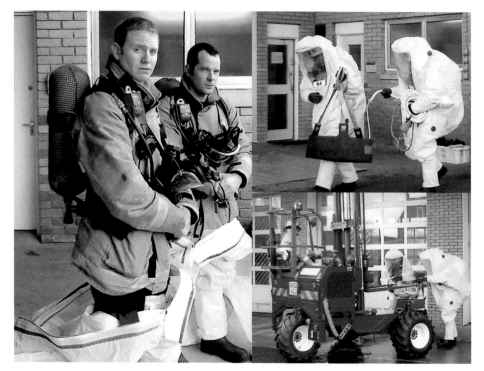

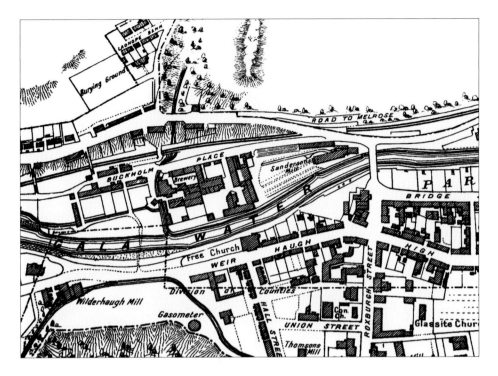

Galashiels Brewery

Galashiels Brewery commenced in 1804 – started by a group of five men including the Revd Doctor Douglas in Low Buckholmside for the 'production of London porter'. A copy of a letter from one James Dalrymple of Edinburgh in 1807 to 'Gallowshiels Brewery' complained 'that the ale was never of any use and it soured on his hand'! This particular brewery closed in 1809 which suggests he may have been right! The new image shows The Ladhope Inn today which sits above the area where the brewery once was. It bears a plaque outside 'Established 1792', proving it much more of a successful venture!

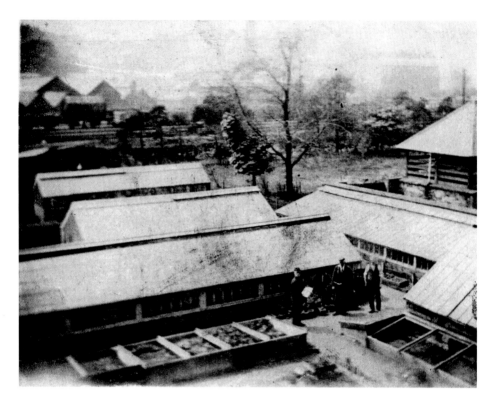

Curry Road Industrial Estate
This market garden stood on the site of what is now Mitchells in Curry Road Industrial Estate. The old railway line can just be seen beyond with signs of Huddersfield Street and Peter Anderson's Mill.

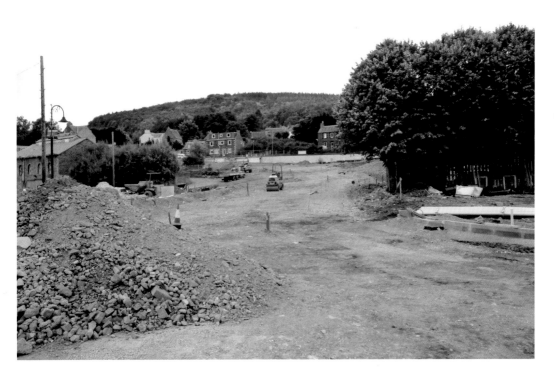

Braw Lads' Brae
The clearing of the old burgh yard in 2006 when the old garage premises, previously occupied by Chalmers McQueen, was demolished to make way for the new 'Braw Lads' Brae'.

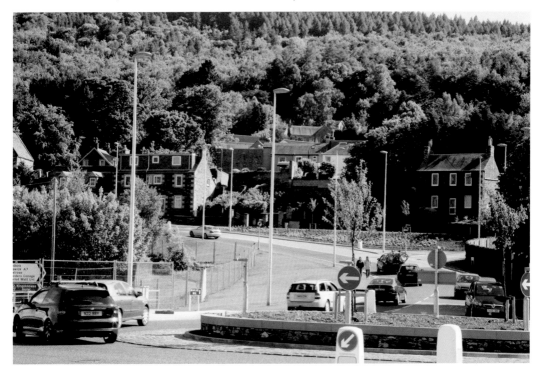

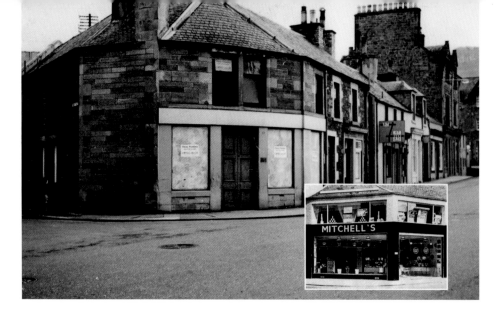

James Beveridge Ltd

This old image shows the premises of what was James Beveridge Ltd, Licensed Grocers. The premises were taken over by Mitchell Glass in 1960, and having changed hands several times since, is now occupied by Quins Restaurant and Coffee Shop. Sylvia Scott and Steven Boggs named their restaurant after Roger Quin, the poet who wrote 'The Borderland' – one of his best loved poems.

"From the moorland and the meadows
To this City of the Shadows
Where I wander old and lonely, comes the call I understand;
In clear, soft tones enthralling,
It is calling, calling, calling –
'Tis the spirit of the open from the dear old Borderland"

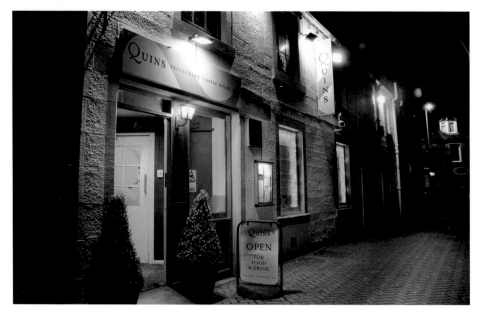

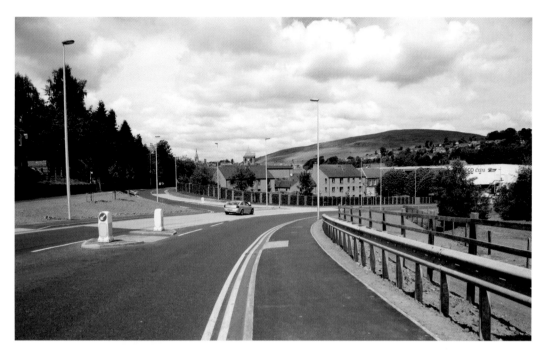

Braw Lads Day' Cavalcade

The Braw Lads' Day photograph in the late 1960s shows the cavalcade heading out along Albert Place after passing the old garage forecourt. The new route from 2010 will involve a right turn on the Gala Day for the riders coming from the Burgh Chambers, not something which is permitted for traffic.

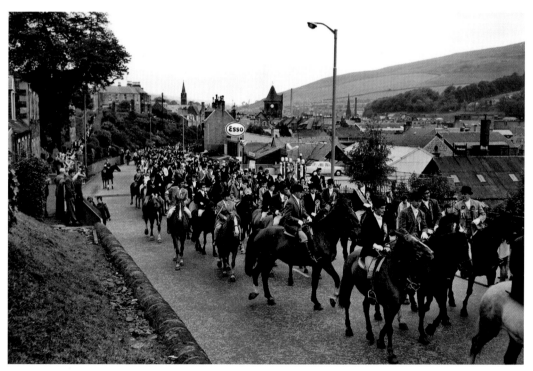

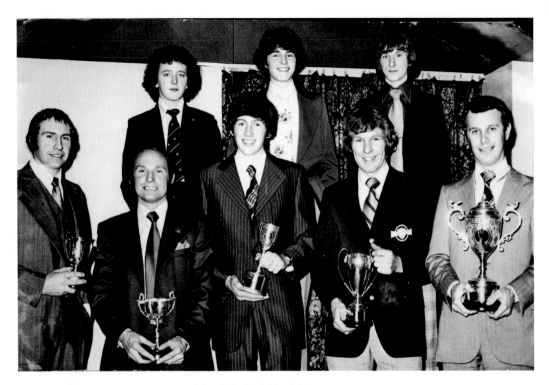

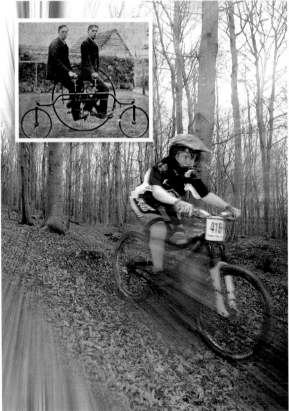

Gala Cycling Club
Gala Cycling Club trophy winners seen in a group picture from the late seventies. In the new image Lynne Aitchison, daughter of Don Aitchison (extreme left in the older image) practises on Gala Hill. Lynne won a second place in the Worlds' Masters Downhill Championship in Canada in 2006. She now does stunt work with schools. Inset an early 'bicycle built for two' photographed at Ladhope House.

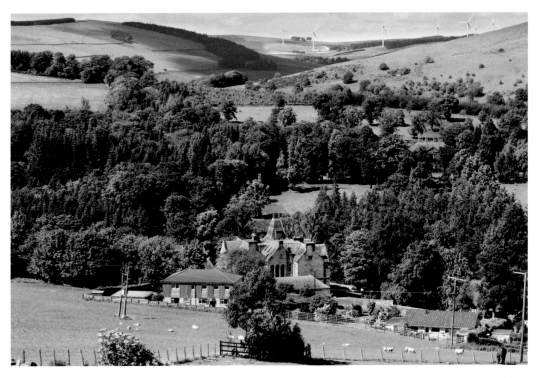

Balnakiel House

Viewed from Meigle Hill, Balnakiel House is lost amongst a new housing estate. The Sisters and staff of St. Mary's Balnakiel ran the house and centre from 1949 to 1991 for women with learning difficulties. The property had been acquired in 1948 by 'The Poor Servants of the Mother of God'. The house, which also had a lovely chapel building with walnut wood panelling is now being sold as private accommodation.

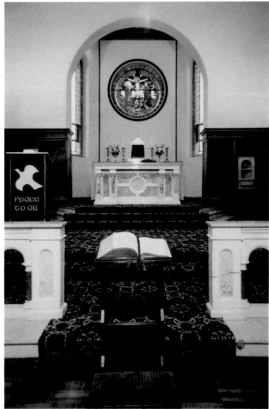

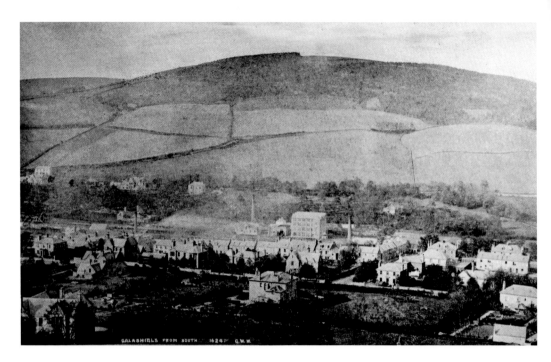

Old Town View

From Gala Hill the old view, *c.* 1880 shows a very sparse town with Abbotsford Road in the foreground. My grandparents' home until 1965 – Eastneuk in Parsonage Road, can be seen on the left. The house had previously been owned by Dr Sommerville, who in the winter months would turn his carriage into a sled to be pulled by his horses. Langhaugh Mill, centre was built in 1875 and burnt down in 1911. The density of the houses now in Melrose Road and Forebrae Park area is quite noticeable.

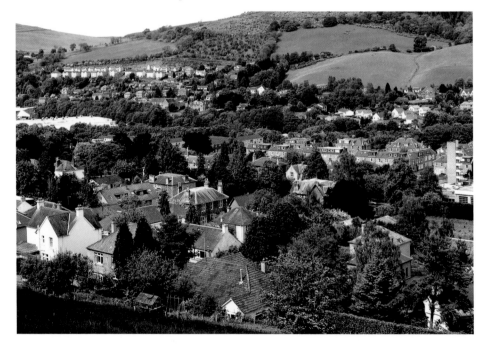

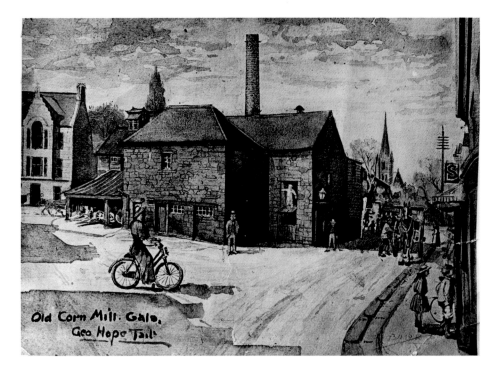

Old Corn Mill. Gale.
Geo Hope Tait

Old Corn Mill

A pencil sketch by George Hope Tait shows an early view of the old Corn Mill. Some artistic licence would appear to have been used, but the library building and the small shops can easily be seen, around the old mill. The latest image shows Scott Paterson, publican of the appropriately named 'Auld Mill', which is situated in Cornmill Square.

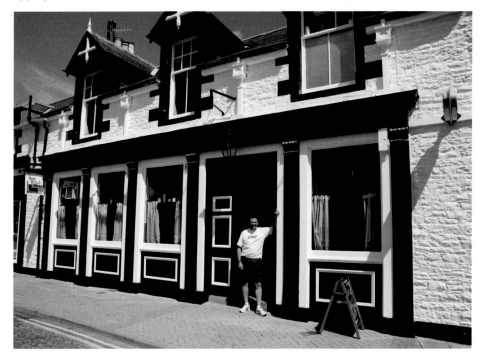

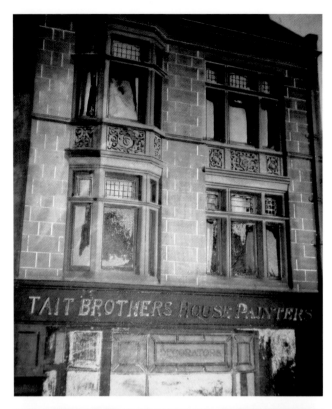

George Hope Tait

Born 1861, George Hope Tait came to live in Galashiels before the time of the first Gala Day. This is a painting he did of the family house and business which he and his brother built at 26 High Street. Inset a copy of one of several large, detailed framed plans, which were never used in the town. The plaques on the Old Town Cross were designed by George Hope Tait and would lead us to imagine he may have had some influence in the first Braw Lads' Day. Records would seem to suggest that he was instrumental in doing research which then had some bearing on the formation of the ceremonies we now see on Braw Lads' Day.

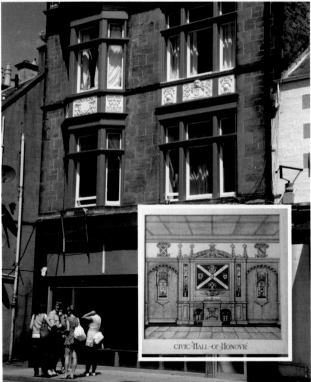

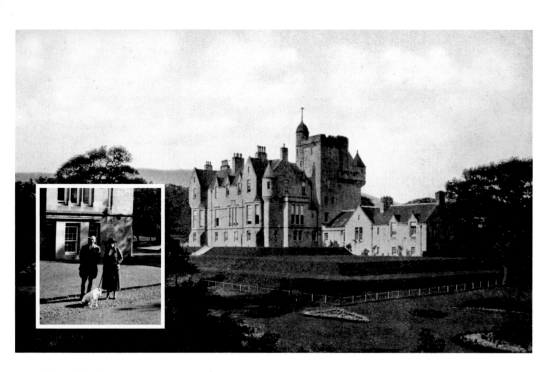

New Gala House

A picture of Mrs Scott MacDougall and her son Hugh Scott (who died at Dunkirk) pictured outside New Gala House, which was demolished in 1987. Built in 1877 it was situated in Gala Policies. It was then sold in 1978 after being vandalised for £7,000. Old Gala House, standing in Scott Crescent, is a popular gallery, museum and meeting place with lovely gardens and facilities.

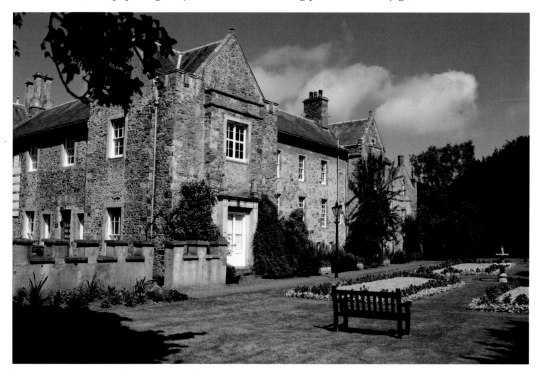

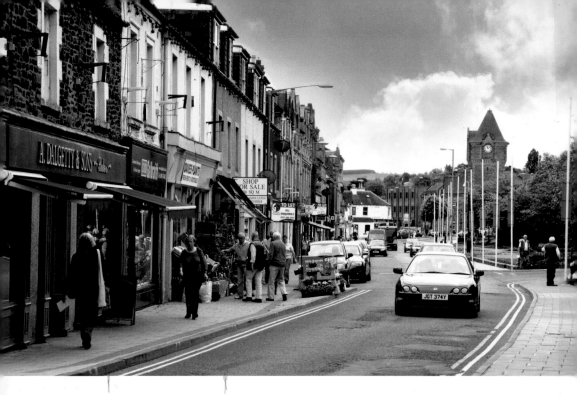

Bank Street

The views from the top end of Bank Street looking down show a similar layout despite there being a 100 year difference, and a missing War Memorial. However, like channel Street, although appearing busy it sadly shows the state of the economy with the many 'Shop For Sale' signs.

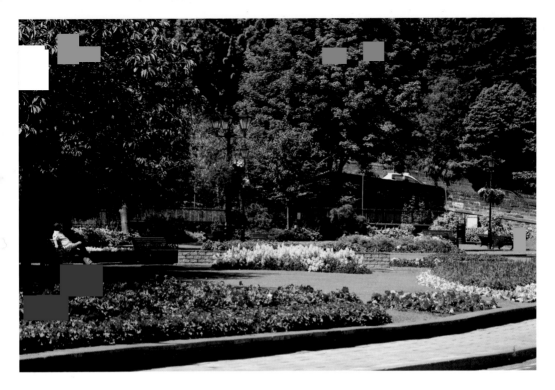

Bank Street Gardens

On the opposite side of Bank Street, the gardens are constantly maintained to a high standard by the park's department and throughout the year provide a lovely floral display for visitors and locals alike.

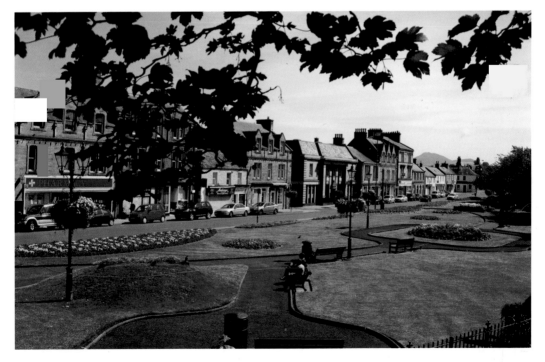

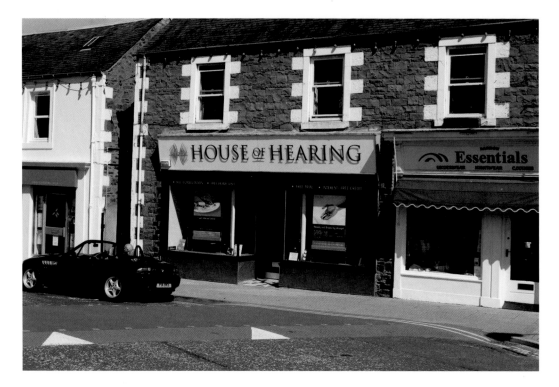

Lipton's Teashop

Bank Street showing what was the Lipton's Teashop and Grocers, around 1930, now the House of Hearing. The old image shows Mr Peters, centre, along with Dick Prosser, George Ramsay, Ella Liddle and Arthur Hancock.

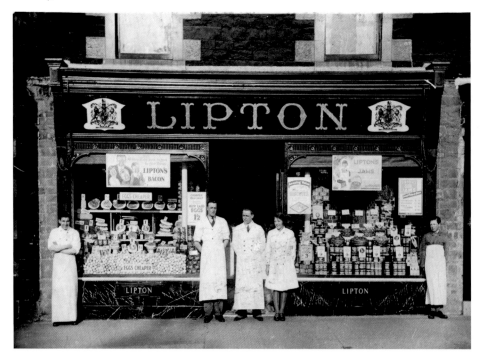

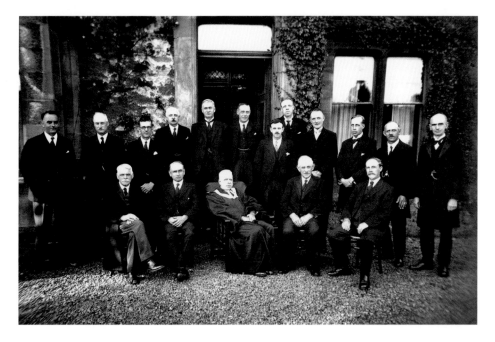

Galashiels Churches

Two quite different Kirk Session photographs. A very austere South United Free Church Kirk Session outside The Manse. At one time there were five united free churches in the town. Trinity Church combined with the South United Free in 1936 and became known as St. Cuthbert's. Situated in Gala Park it then became Ladhope St. Cuthberts and in the early eighties St. Aidans. It united with the congregation of St. Ninians in the High Street in 2005 and the two congregations took the name of 'Trinity' once again. The new image shows the Trinity Kirk Session and Congretational Board with their Minister, Revd Morag Dawson.

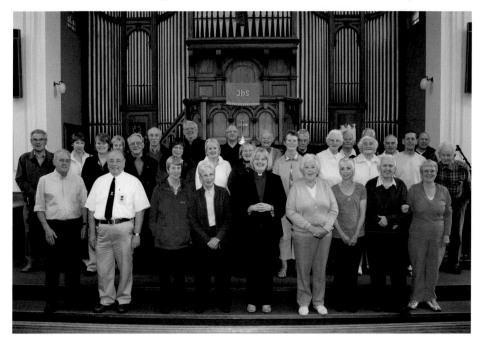

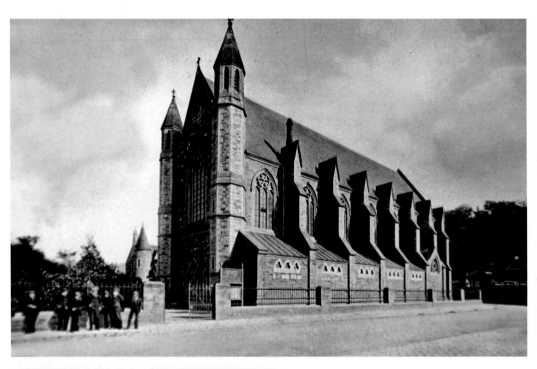

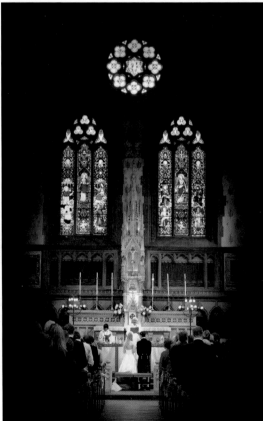

Church of Our Lady & St Andrew
Church of Our Lady & St Andrew, completed in 1858 and extended in 1870. This exterior remains almost unchanged today, however the gentlemen in the old image would get quite a shock at the amount of fast flowing traffic if they suddenly were transported back to that particular corner. The new road which comes along the front gates of the church carries traffic into the town centre and beyond. The interior of the church, with lovely stained glass windows and altar is a joy to use for a wedding photographer.

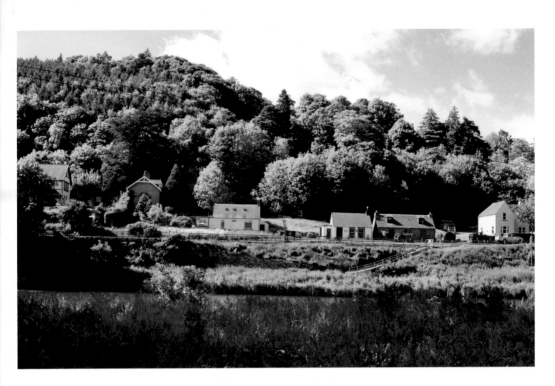

Crossing the Tweed

Once a busy ferry crossing carrying passengers across The Tweed. The train would stop at Abbotsford Ferry Station allowing passengers to catch the ferry to Abbotsford. The mock Tudor style houses, built in the early 1900s by Adam Grieve, can still be seen. In 1723 a boat, carrying a number of people and a horse, broke free from moorings opposite Abbotsford and travelled to Galafoot before overturning, drowning eighteen people. It is reported that 'The Session considered this a token of the Lord's anger'!

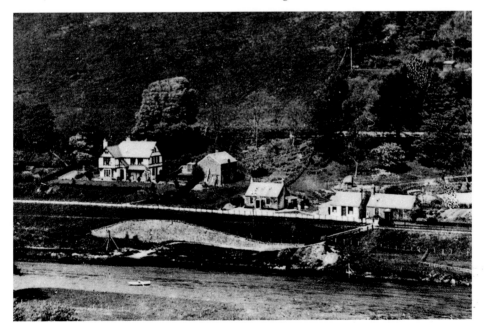

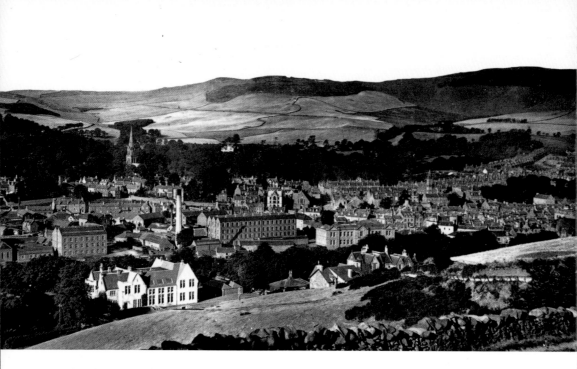

Bruce's Hill
From Bruce's Hill with a view quite changed now in 2010, and being dominated by the white roofs of Tesco and Next.

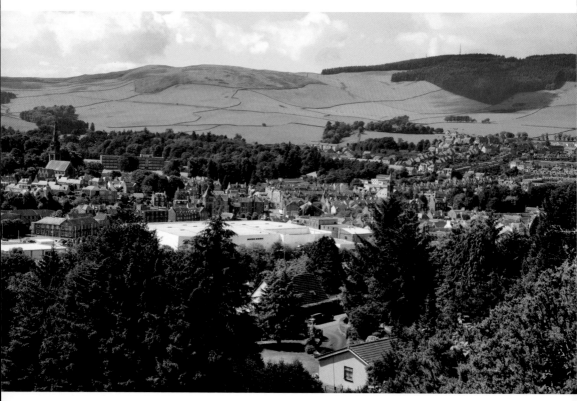

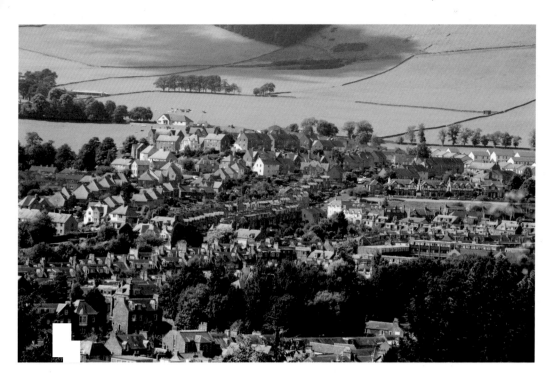

Modern Views

These two 2010 views from the same spot show the town nestled amongst trees and showing views across to Eildon Street, Meigle Street and Mossillee in the top image and Huddersfield Street, Parsonage Road and St Peter's Church in the other.

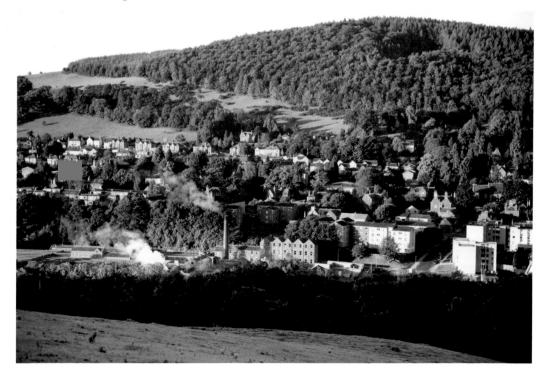

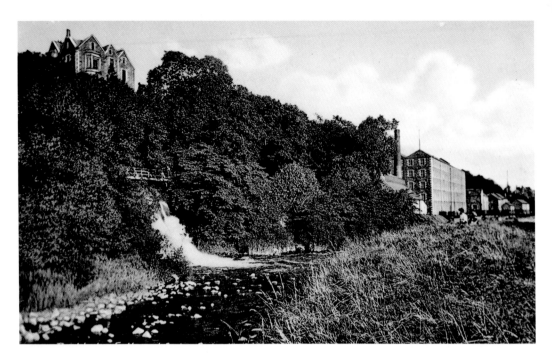

Buckholmburn Falls

Buckholmburn Falls just appearing below Buckholm Burn House top left. Buckholm Mill, which closed in the early seventies, can be seen in the distance. All that remains of Buckholm Falls is an unusable walkway and the old workings of the sluice covered in tree branches and foliage.

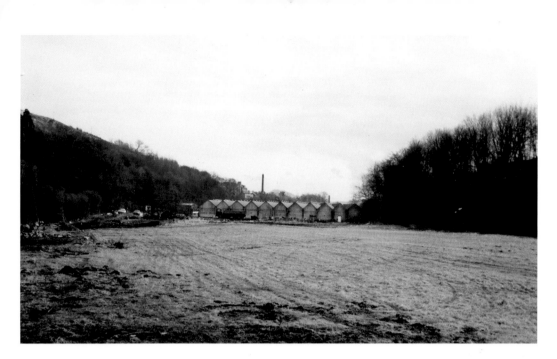

Buckholm Burn

This large expanse of land looking back to Buckholm Burn (seen top left amongst the trees) was acquired by S. & I. Thomson, an Auto Salvage company, in the early 1980s. This land at one time was a sand quarry, then a market garden. The old buildings seen in the distance, now owned by the Wool Marketing Board, once stored essential supplies during the war years, such as gas masks etc. The new image shows Ian, Stewart, Gillian, Julia and Keith Thomson in the front of part of their yard and offices.

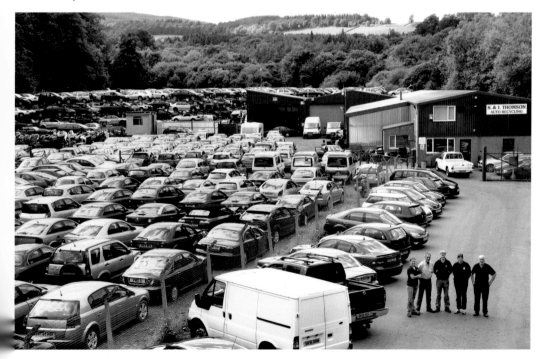

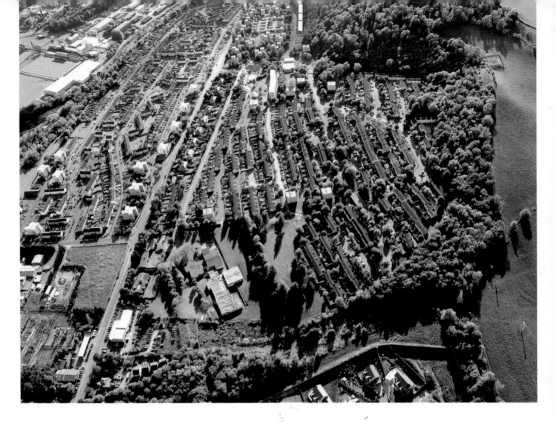

Galashiels from the Air
Galashiels photographed from a Micro Lite, showing the Langlee, Melrose Road, and Netherdale area of the town.

Acknowledgements

The credit for this book must go to my uncle, Jim Walker – born in Galashiels, himself an author of seven books and Fellow of the Royal Photographic Society. He has encouraged me and guided me every step of the way. He must also take responsibility for my present occupation as a photographer.

My grateful thanks also to Justin Mihulka, Ron Ballantyne, Ewan Doyle, Effie Devlin, Neta Weatherly, Philip Macari, Sylvia Mitchell, Kirsty and Jamie Houghton, Jan Parker, Phyllis Hancock, Craig Murray, Mary Young, Jim Lees, Neil Crooks, Don Aitchison, Borders College, John Gray, the Codona family, Bill Lamb, Graeme Howlieson, Moira Whyte, Bill Brodie, Gary Adams, Cameron Architects, Lewis Roden, Carolyn and Isobel at Gala Day Services, Morag Dawson, Gillian Thomson, Scott Bell, Scott Paterson, Tom and Charlotte Stanners, Joyce Maltman, Ian Briggs and all who assisted me with this book.

Last but not least my husband Harry and best friends Gail and Pat who have 'walked Gala' with me up hills and down in the pursuit of the closest spots to photograph the new version, and Sandra Aitchison – the most enthusiastic and proud Galalean I know!